IMAGES
of America

LOST GALVESTON

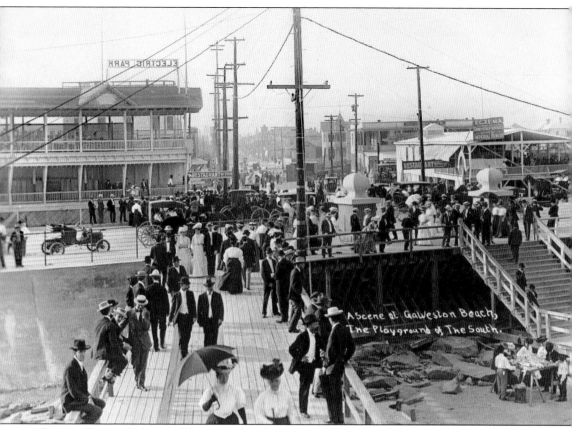

A Scene at Galveston Beach,
The Playground of The South.

ON THE COVER: Galveston Electric Park and Amusement Company incorporated in early 1906 and was opened on May 26, in time for the summer crowds. The first attractions included a summer theater, a carousel, a bandstand and a series of booths for fruit and candy vendors, as well as the beach. Two markers of Texas Red granite were installed in 1904 at the intersection of Tremont Street and Seawall Boulevard to commemorate the construction of the seawall. (Courtesy Galveston County Historical Museum.)

IMAGES
of America

LOST GALVESTON

Brian M. Davis

ARCADIA
PUBLISHING

Published by Arcadia Publishing
Charleston, South Carolina

Printed in the United States of America

Library of Congress Control Number: 2009941021

For all general information contact Arcadia Publishing at:
Telephone 843-853-2070
Fax 843-853-0044
E-mail sales@arcadiapublishing.com
For customer service and orders:
Toll-Free 1-888-313-2665

Visit us on the Internet at www.arcadiapublishing.com

*To my family, whose encouragement and support
challenged me to learn more about the past*

CONTENTS

ACKNOWLEDGMENTS

I would like to thank the writers, photographers, and surveyors who have taken the time to document Galveston's history so that we can continue to learn from it: Lillian Herz, the Paul Verkin family, Howard Barnstone, Ezra Stoller, Henri Cartier-Bresson, Ellen Beasley, Stephen Fox, Drexel Turner, Barrie Scardino, Margaret Doran, Larry Wygant, Sallie and Dr. Jack Wallace, Dr. Burke Evans, Bill Leopold, Mary Remmers, Maggie and Ennis Williams, Jodi Wright Gidley, Jennifer Marines, Betty Massey, and the Mary Moody Northern Endowment. The Galveston Historical Foundation's Preservation Resource Center grows with each photograph or book about the island's past, which is shared and made available to others. I would like to thank Margaret and V. J. Tramonte, John L. Richardson, Lisa Trouth, and Eloise Powell for sharing their images of Galveston.

Jodi Wright Gidley and Jennifer Marines at the Galveston County Historical Museum and the staff of the Dolph Briscoe Center for American History at the University of Texas at Austin have been very helpful in the quest to compile this collection. To Margaret Doran, thank you for your assistance, for sharing your knowledge, and for the countless hours you give to GHF. A special thanks goes to Dwayne Jones, Denise Alexander, Jami Durham, and the staff and board of directors of the Galveston Historical Foundation. Without this teamwork that we share, Galveston would look much different

Unless otherwise noted, photographs appear courtesy of the Galveston Historical Foundation's Preservation Resource Center.

Other collections noted include:

Historic American Building Survey (HABS), National Park Service collection in the Library of Congress

Verkin Collection, the Dolph Briscoe Center for American History, the University of Texas at Austin

Galveston County Historical Museum collection, Galveston, Texas

Finally, I would like to thank the members of the Galveston Historical Foundation. Your continued support helps ensure that not all of Galveston will be lost.

INTRODUCTION

This collection of photographs and stories began after seeing images of historic Galveston buildings and realizing what now stood on their former sites. There is often little chance in stopping the construction of new development and even less chance in stopping fires and storms, which have wrecked millions of buildings across the country. As preservationists, from professionals to owners of historic buildings, we must all continue to maintain and use these structures or else they will fade into the past. With each building that is lost, a part of that community's character is erased.

Often, as buildings are left vacant and neglected, they become associated with less than desirable activities or appearances. This makes them targets for vandals and concerned citizens, who want the building demolished in an effort to clean up a neighborhood. It takes a creative and determined person to discover how these buildings can be put back into use in a way that supports the community. This book shows buildings in Galveston that were demolished, but the problem of neglected structures stretches across the nation.

Many Galveston buildings from the 19th and 20th centuries remain today because of the depressed economic conditions of the city at the time when other cities were replacing historic structures with new development. The gas station was a sworn enemy of many houses along Broadway Avenue, and nearly overtook Ashton Villa (2328 Broadway Avenue) and the Walter Gresham Residence (1402 Broadway Avenue), also known as Bishop's Palace. For Galvestonians from the 1940s through the 1980s, the site of a building being razed was commonplace.

As ownership and uses of buildings change, so do the lives of their inhabitants. What I present here are small glimpses into those lives as seen through newspaper articles, advertisements, city directories, and other written or oral accounts. It is not intended to reflect the complete potential or story of the buildings and people mentioned, for that would take volumes.

With each hurricane, fire, or demolition, more of Galveston's history fades from memory, not just with buildings, but also the photographs, books, and letters that are destroyed. For someone restoring a historic home or researching past owners, each of these may be the key to solving a mystery.

We often long for the buildings that are lost and the memories they once held within their walls. The same was true in 1887 as the last pieces of the market house were being removed so construction could begin on Muller's Galveston City Hall. The following was printed in the *Galveston Daily News* on Friday, September 23, 1887.

> The old market house on the corner of Market and Twentieth Streets has almost succumbed to the hand of reform, and will soon be a thing of the past. Only the skeleton frame now stands upon the site, and even this will soon be leveled to the ground. Surroundings in this vicinity naturally bear a strange aspect in the absence of the familiar old structure, which could many a tale unfold were its timbers possessed of tongues. But all of its reminiscences will be lost to memory when the site is covered by a new and improved structure.

I invite the reader to visit the locations mentioned in this book and imagine not only the buildings, but also the craftsmen and inhabitants of a lost Galveston.

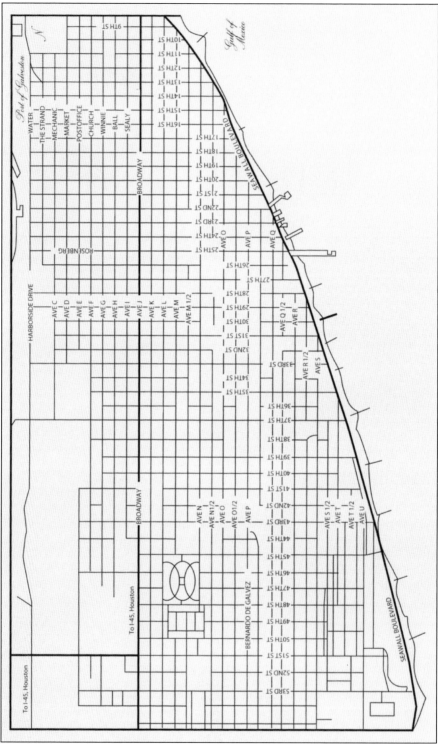

This is a map of the city of Galveston. Even street numbers are located on the north and east sides of streets, and odd numbers are located on the south and west sides.

One

HOTELS, CIVIC BUILDINGS, AND SOCIAL PLACES

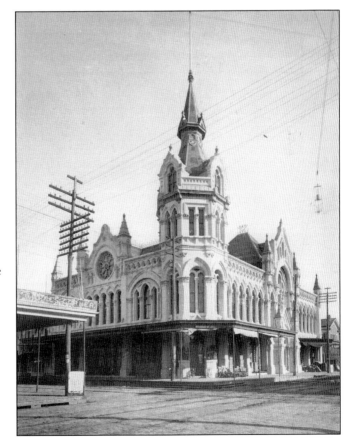

Constructed for Harmony Lodge No. 6 A. F. and A. M. of the Masons of Galveston, this Nicholas Clayton–designed building stood at the southeast corner of Twenty-first and Postoffice Streets. Dedicated on April 17, 1884, it cost $41,330 to construct. The roof and corner turret were removed by the 1900 storm. The second floor was destroyed by a fire in 1942, and a subsequent blaze destroyed the remaining ground floor in 1966.

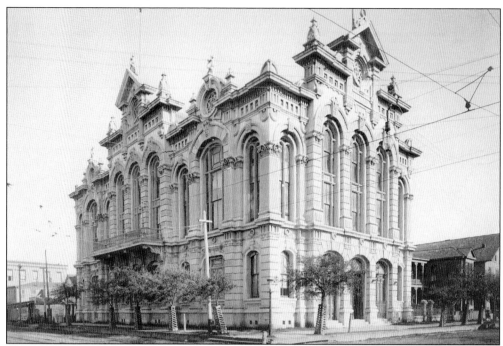

Ryland Chapel, Galveston's first Methodist church building, occupied this site until being moved in 1881 to make way for Harmony Hall. Nicholas Clayton completed this structure at 2128 Church Street for the Harmony Hall Association in 1883. It was later the Galveston Business College and, in 1902, became the Scottish Rite Temple. Faulty wiring in an organ started a fire on the evening of February 5, 1928, destroying the building.

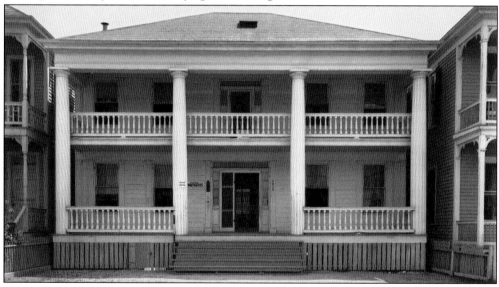

Turner Hall was built in 1858 by the Turn Verein Lodge at 2015 Sealy Street and was used by early Germany settlers for dramatic performances, shows, and dances. It was one of the earliest social halls in Galveston. It was later an office for Charles S. Ott's marble and granite works, a residence, and apartments. The State of Texas demolished it in 1975 for construction of a warehouse. (Courtesy HABS.)

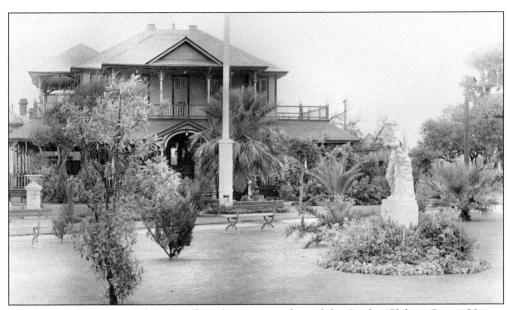

In February 1876, a group of German-born businessmen formed the Garden Club, or Garten Verein. They purchased the homestead of Robert Mills at the northwest corner of Twenty-seventh Street, and Avenue O. Alfred Muller designed this clubhouse in 1891, which was demolished in 1923. The land was sold that year to Stanley "Pat" Kempner, who donated it to the city as Kempner Park, in honor of his parents, Harris and Lyda. (Courtesy Galveston County Historical Museum.)

When the Swiss-born banker and philanthropist Henry Rosenberg died at his home in 1893, he left $65,000 in his will to construct a suitable building for the Young Men's Christian Association (YMCA) of Galveston. Designed by Charles W. Bulger, it was the first YMCA building in the state and sat at the southwest corner of Twenty-third and Winnie Streets until being demolished in 1954.

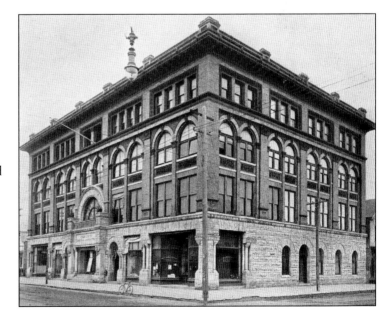

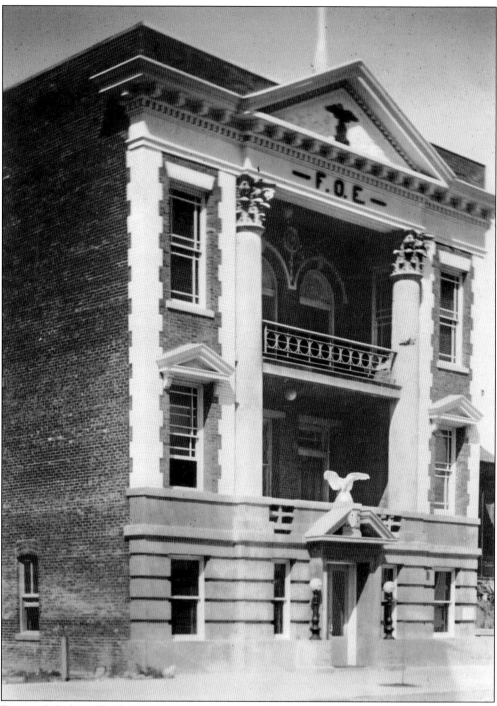

Fraternal Order of Eagles No. 48 incorporated in 1902 and constructed their meeting hall, or aerie, at 1906 Postoffice Street around 1915. This building stood until being damaged by a tornado during Hurricane Carla in 1961. It was condemned and demolished two years later. A new aerie stood on the site until it was destroyed by fire during Hurricane Rita in September 2005. (Courtesy Galveston County Historical Museum.)

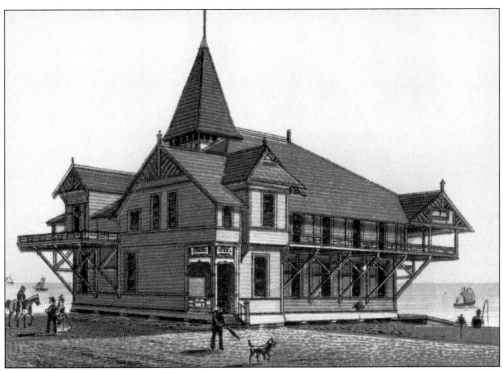

When improvements by the Galveston Wharf Company blocked the previous boathouse from the harbor, the Island City Boating and Athletic Association commissioned William H. Roystone to design this structure at Fifteenth Street and the bay. Completed in 1888, it served the yacht racing and rowing teams until the wharf company needed more space. This building was demolished after a new boathouse was constructed at Tenth and Market Streets in 1893.

Architect A. J. Armstrong of Dallas designed the Gulf, Colorado, and Santa Fe Railroad terminal in 1897. The railroad was incorporated in Galveston in 1872 by local citizens, with a goal of bypassing Houston. Armstrong's station was demolished in March 1931 to make way for a new office and terminal building. The 11-story tower of the replacement building occupied Strand Street at the west side of its intersection with Twenty-fifth Street.

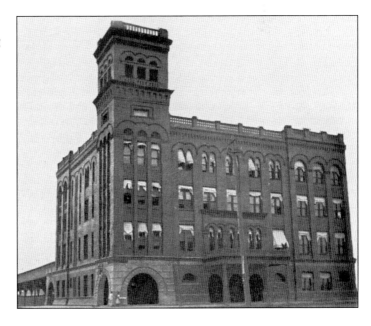

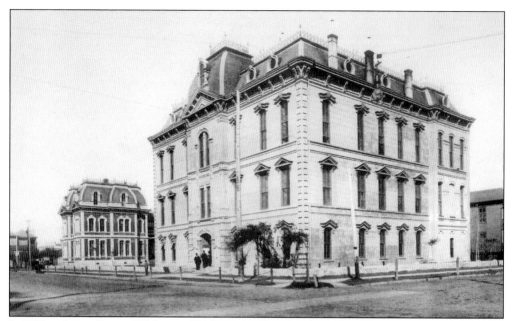

In 1881, architect Eugene T. Heiner added a mansard roof to the 1857 Galveston County Courthouse to provide more space. This structure was destroyed by fire on December 16, 1896. Heiner designed the building in the background in 1879 as the county jail. It later housed the first appellate court in the state of Texas. This structure was demolished in 1965 to build a new courthouse and jail facility at Twentieth and Winnie Streets.

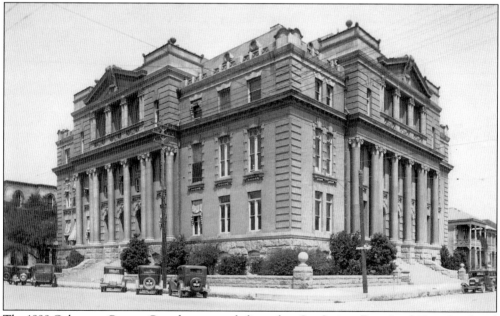

The 1899 Galveston County Courthouse was dedicated on San Jacinto Day, April 21, and replaced a building destroyed by fire three years earlier. The Fort Worth architectural firm of Messer, Sanguinet, and Messer was awarded the commission over Nicholas Clayton. This building was damaged in Hurricane Carla, and citizens voted to demolish it, along with the old court of appeals, instead of making repairs. The last bricks were removed in December 1965.

14

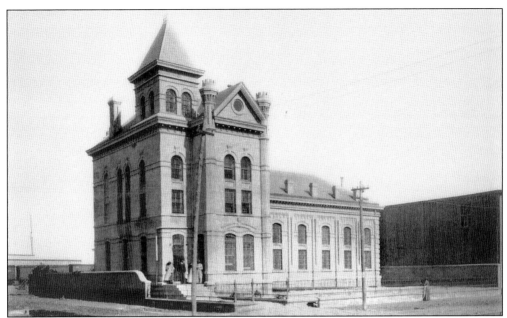

Galveston's first county jail was the brig of a German ship, *Elbe*, which became stranded around Twenty-ninth Street and Strand Street in October 1837. The first frame jailhouse was constructed in 1840 at Twentieth and Winnie Streets. Houston architect Eugene T. Heiner completed this jail in 1890 at the northeast corner of Seventeenth Street and Avenue A. It was demolished in March 1913 after being condemned as unfit for asylum purposes.

This complex replaced the 1890 Galveston County Jail and was completed in late 1913 on the same site as the earlier one. Designed by Galveston architect D. W. McKenzie, the cost of the structure was $65,000. An annex was added in 1930 and served the county until being abandoned in 1963, once a new jail was constructed. The structure was demolished in February 1965.

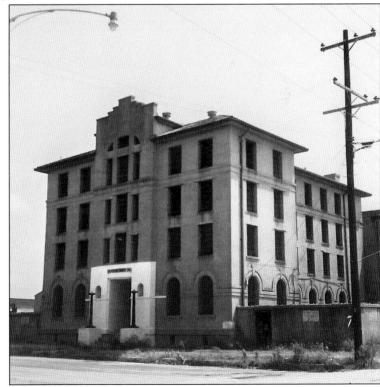

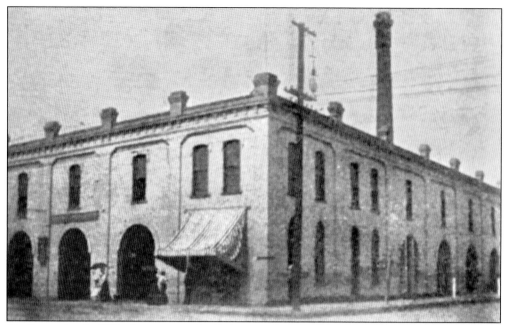

On September 2, 1890, the city gave the Galveston City Railroad Company the right to electrify its lines. Fifteen months later, electric streetcars began to replace mule-pulled railcars. The tracks were demolished in the 1900 storm, along with this structure at the northeast corner of Twenty-first and Sealy Streets, which contained stables, a car garage, and a granary. Electric streetcars operated after the grade raise until 1937, when the first city bus ran.

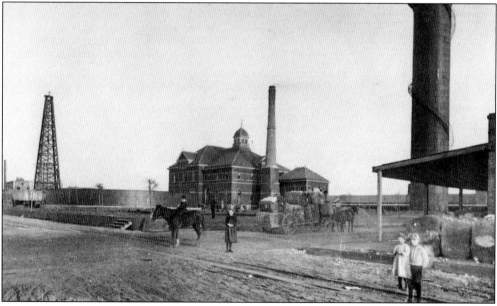

On March 29, 1887, the Texas Legislature created the Galveston Waterworks to assist in extinguishing fires and improving public health conditions in the city. Until this time, cisterns were the source of water for residents and contributed to yellow fever outbreaks. This pumping station was constructed at the northeast corner of Thirty-first and Ball Streets in 1888 and was destroyed in the 1900 storm.

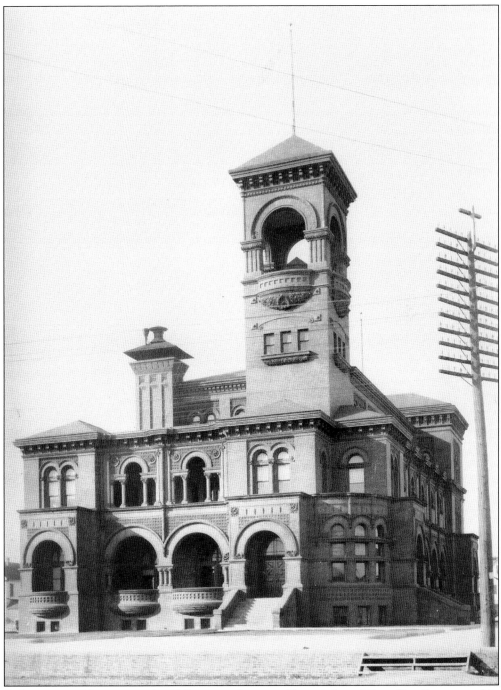

Galveston quickly outgrew the 1861 custom house at Twentieth and Postoffice Streets, and in 1891, this custom house, courthouse, and post office was completed at the southwest corner of Church and Twenty-fifth Streets. Although there were several architects for the U.S. Treasury during the project, Nicholas Clayton was the supervising architect and reviewed the day-to-day work. This building was demolished in 1935 to make room for a new federal building, custom house, and courthouse, which consumed the entire block.

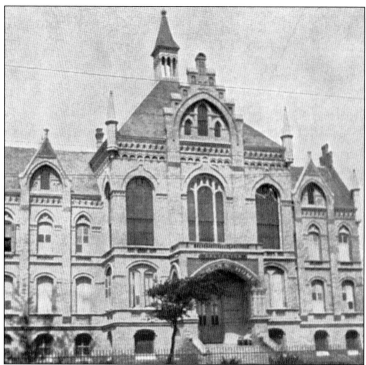

Alfred Muller's 1895 Island City Protestant and Israelitish Orphan Home at Twenty-first Street and Avenue M survived only five years before being destroyed in the 1900 storm. Newspaper mogul William Randolph Hearst held a bazaar at the Waldorf-Astoria Hotel in New York shortly afterwards. This event, along with donations from readers and Hearst, raised a substantial amount to rebuild an orphanage at this location for those children who lost their parents during the storm.

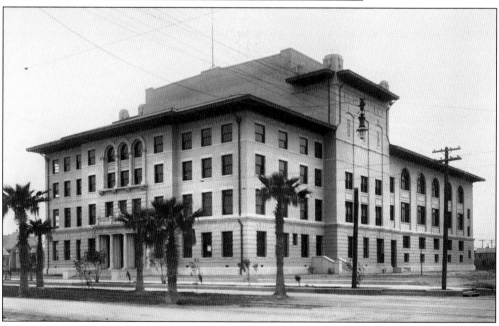

Built in conjunction with a new city hall in 1915, the city auditorium played host to numerous cooking schools, beauty schools, demonstrations, dances, plays, public meetings, graduation programs, and beauty pageants, among other events. The complex was designed by the Dallas firm of C. D. Hill and Company in the manner of the City Beautiful movement. The auditorium was damaged in Hurricane Carla and was demolished in the summer of 1963, while city hall remained. (Courtesy Galveston County Historical Museum.)

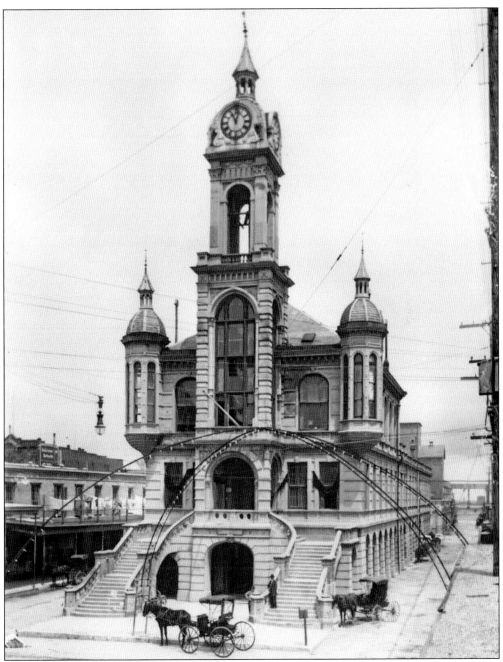

Alfred Muller's design won out over those of three other architects for the city hall and market house of 1888. It replaced an earlier market house from 1846 in which Mayor John Sydnor shifted the four city lots east along Twentieth Street between Strand and Market Streets to allow passage on both sides of the market. The ground level of Muller's design held a meat market, with city offices and the police station above. The third floor housed city offices and the chamber of commerce. Heavily damaged by the 1900 storm, it was later converted into a firehouse. It was demolished in 1965, and the site became a median and parking spaces. (Courtesy Dolph Briscoe Center for American History.)

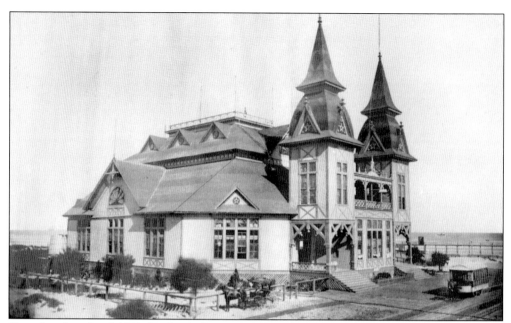

Completed in April 1881 for the Galveston City Railway Company, the Galveston Pavilion, a Nicholas Clayton design, was located on the east side of Twenty-first Street at the beach. It played host to the state's Saengerfest, or "singer's festival," that year. Oscar Wilde lectured on "Decorative Art" here in June 1882 while on tour. The structure also played host to the Texas Democratic State Convention the following month. A fire started in the pavilion at 1:45 p.m. on August 1, 1883, and within an hour, the entire structure was a smoldering ruin. (Courtesy Holley and Scott Hanson.)

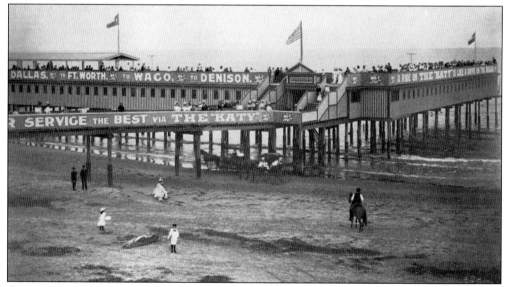

George Murdoch managed the Pagoda Bath House before building his own establishment at Twenty-fifth Street and the beach. Numerous storms demolished the business, but Murdoch continued to rebuild, attracting visitors to the beachfront. After it was destroyed in the 1900 storm, Murdoch rebuilt this structure at the foot of Twenty-third Street. Advertisements for the Missouri-Kansas-Texas Railroad, also called the Katy, covered the building.

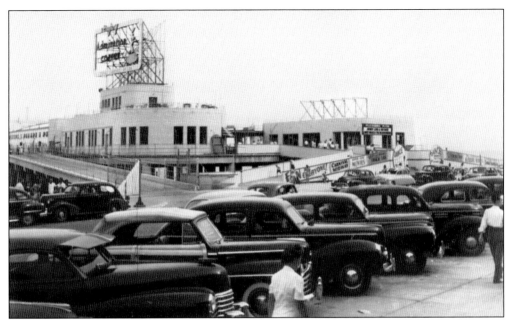

For nearly 20 years, the Pleasure Pier took center stage at Splash Day, an annual beach season opening traditionally held on the first weekend in May. First held in 1916, the event featured parades, fireworks, water-ski shows, exhibitions, weight-lifting competitions, a dance, and the crowning of Mr. and Miss Splash Day. The official event was discontinued in 1965 after crowds became too large to safely control.

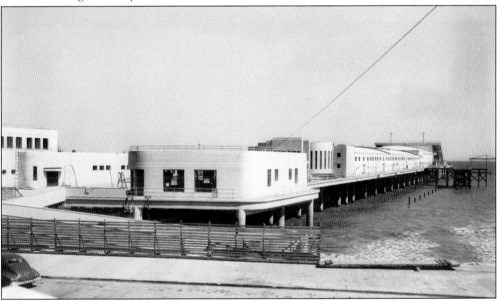

The Galveston Pleasure Pier was completed in 1943 according to plans and materials approved before the outbreak of World War II. It extended 300 feet into the gulf and was supported by 135 reinforced-concrete caissons. A café, a concession stand, a display hall, and a convention hall led to an open-air stadium and fishing platform at the end. Hurricane Carla damaged the structures on the pier, which were replaced by the Flagship Hotel. (Courtesy Galveston County Historical Museum.)

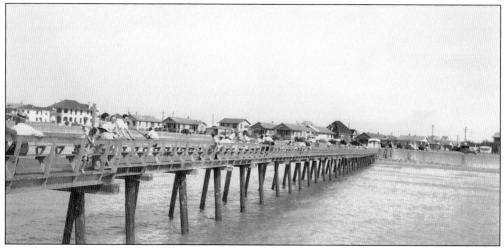

Galveston County judge E. B. Holman opened the Free Fishing Pier at the foot of Seventeenth Street and Seawall Boulevard on August 15, 1938. It was 808 feet long with a T-shaped end at nearly 150 feet in length. One-third of the pier washed away in a storm that hit Freeport in October 1949, but it was repaired. The pier was totally destroyed by Hurricane Carla on September 11, 1961. (Courtesy Lisa Trouth.)

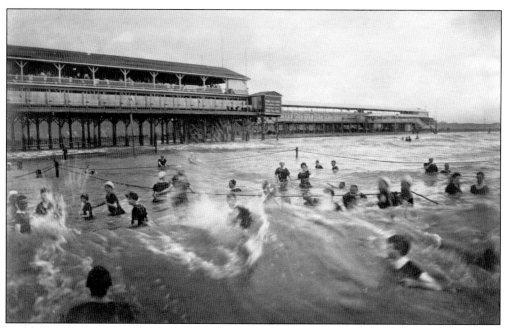

Bathhouses were constantly changing and adding features to keep the experience fresh. Here, at the Breakers, visitors could swim in the warm gulf waters and partake in hot salt water, Turkish or electric baths, or massages. These establishments also sold inexpensive items such as photographs, postcards, and sea shells that tourists could take or mail back home to show friends and family. (Courtesy Galveston County Historical Museum.)

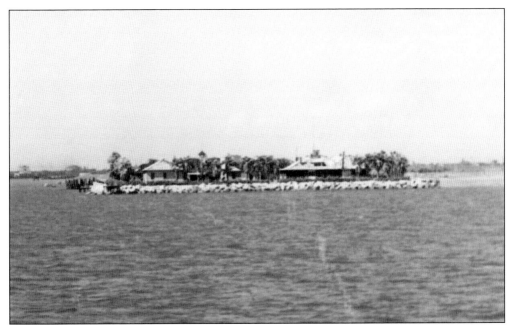

Hundreds of thousands of immigrants entered the country through Galveston in the 19th and 20th centuries. This immigration and quarantine station was completed by the U.S. government in 1915 at the eastern tip of Pelican Island and was closed in 1950. These buildings were demolished in 1972 to make room for Seawolf Park, a popular location for fishing. (Courtesy Lisa Trouth.)

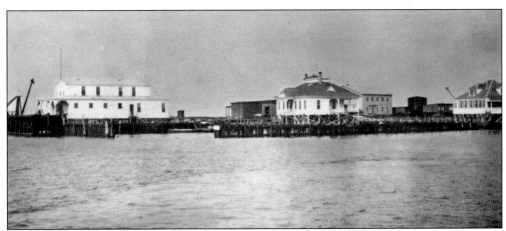

Galveston's first quarantine station was built in 1853 and was destroyed by the hurricane that hit Indianola on September 16, 1875. Ships bringing passengers or cargo that may carry diseases were detained until given an inspection and clearance. This lifesaving station and state quarantine station, built after the 1900 storm, was located just north of the Bolivar Ferry Landing. (Courtesy Galveston County Historical Museum.)

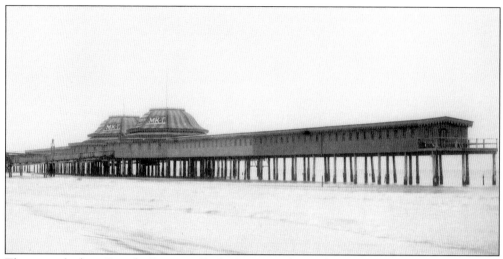

The exotic-looking Pagoda Company Bath House was hoisted on 14-foot piers over the Gulf of Mexico at the intersection of Twenty-fourth Street and Avenue R. It featured two long wings that ran parallel to the beach, a platform facing the gulf, and a photography studio. It was situated between the Gulf Bath House and G. Murdoch's Bath House, all three of which were destroyed in the 1900 storm.

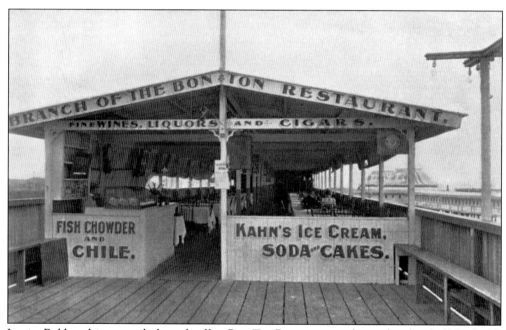

Louise Baldarachi operated a branch of her Bon Ton Restaurant at the rooftop level of Murdoch's Bathing Pavilion at Twenty-fifth Street and the beach. Its main location was at 2208 Market Street (see page 121). That location advertised a ladies' dining room with a separate entrance attached and regular meals for 3¢. The 1900 storm destroyed Bon Ton "On the Sea," along with the rest of Murdoch's Bath House.

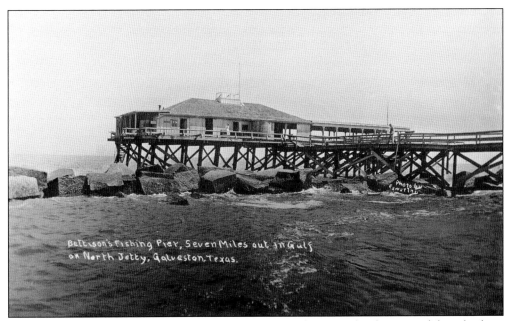

Thirty-eight fishermen were removed from Bettison's Fishing Pier by the crew of the pilot boat *Texas* before it was destroyed in the hurricane that struck the region on July 21, 1909. The pier was located 7 miles northeast of the city, at the end of the North Jetty, and brought visitors in from the harbor by boat. In a city directory advertisement, it boasted "The coolest spot in Texas. No mosquitos." (Courtesy Galveston County Historical Museum.)

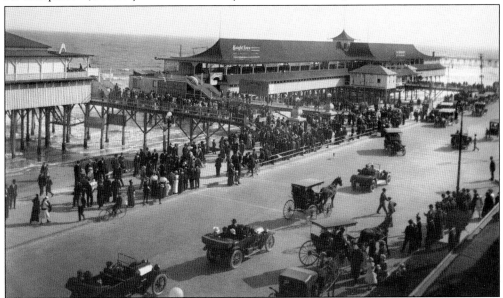

This version of the Breakers Bath House was constructed around 1910 at a cost of $45,000 and was destroyed in a hurricane five years later. After the 1915 hurricane, voters defeated a city charter amendment to outlaw any construction south of Seawall Boulevard over fears that wreckage of the structures could slam against other buildings. The proprietors of Murdoch's and the Breakers bathhouses pled their case and won. Only Murdoch's chose to rebuild. (Courtesy Galveston County Historical Museum.)

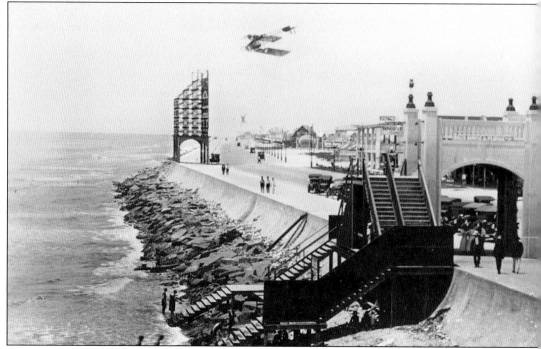

Designed by the firm of Orlopp and Orlopp, the 1916 Crystal Palace facility offered visitors a bathhouse, a theater, and a hotel, as well as a concrete causeway over Seawall Boulevard. Modifications in 1919 increased the dance floor to 9,000 square feet, making it the largest in the

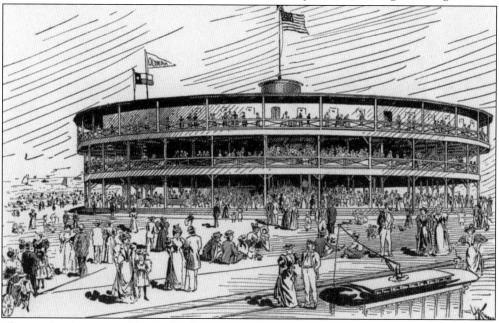

The circular, three-story Olympia by the Sea pavilion featured a dance hall, a restaurant, and other amusements. Located at the east side of Twenty-sixth Street and Avenue R, it was completed in 1896 and was destroyed four years later during the 1900 storm. Its former location is where the surf meets the beach, just west of Twenty-fifth Street.

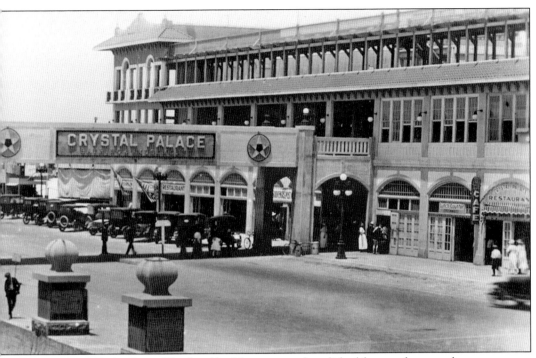

state. In 1941, the Crystal Pool and bathhouse were demolished for storefronts and an amusement park. It was located on Seawall Boulevard between Twenty-third and Twenty-fourth Streets. (Courtesy Galveston County Historical Museum.)

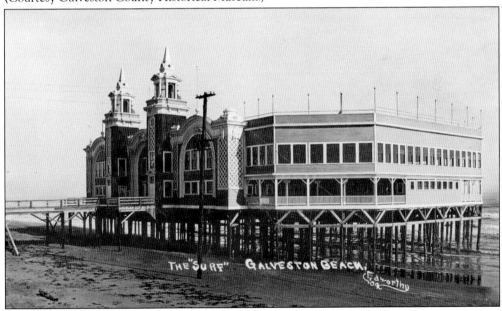

The Surf Bath, located at 3225 Seawall Boulevard, was designed by local architect Donald N. McKenzie in 1903. It sustained only slight damage in the hurricane of 1909, when Murdoch's Bath House and the Breakers were destroyed. The powerful hurricane that made landfall to the southwest of the city on August 17, 1915, destroyed this structure. (Courtesy Galveston County Historical Museum.)

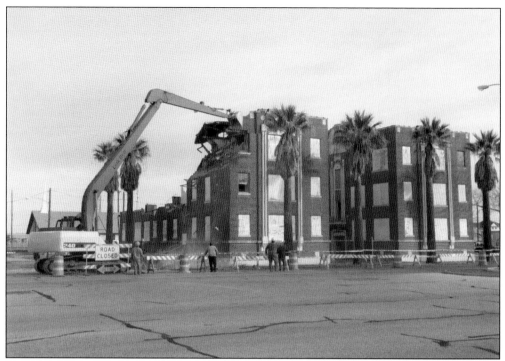

Touted as Galveston's first modern apartment houses, the Broadmoor Apartments, at the northeast corner of Twenty-ninth Street and Broadway Avenue, opened on October 1, 1923. Galveston architect Joseph Finger designed the structure for W. L. Moody Jr.'s American Realty Company. The building sat vacant after years of service, and the roof of the western half was allowed to collapse. The brick and decorative concrete structure was demolished on February 18, 2010.

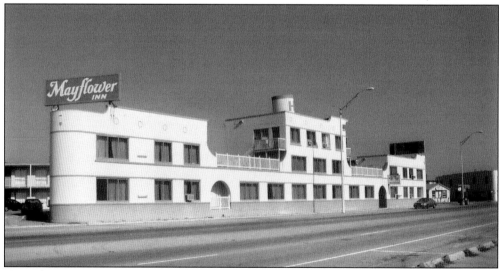

The Hill brothers, local restaurateurs, commissioned Galveston architect Ben Milam to design the SS Galveston Hotel Courts at 802 Seawall Boulevard in 1941. Elements of this mimetic structure resembled a cruise ship, with rhythmic decks, rails, and a smokestack. The windows were blown out of the building during Hurricane Carla, when it was the SS Snort Hotel. It later was used as apartments before being demolished in 2006 for real estate speculation.

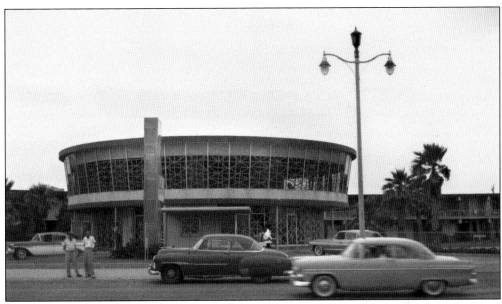

Galveston architect Thomas M. Price designed the 106-room Seahorse Motel with John T. Buckhart in 1956. This replaced the Miramar Courts, built by W. L. Moody Jr. in 1928. A sweeping arc of rooms arranged around a central office and restaurant building afforded each room a view of the gulf. The structure was demolished in 2005. (Courtesy Galveston County Historical Museum.)

The St. Nicholas Hotel was built in 1908 at the northeast corner of Twentieth and Market Streets, on a site occupied by saloons and several Chinese laundries in the 1880s. This establishment was known by several other names, including the Davis Hotel, Gentleman Jim's Hotel, and later the Alvin Hotel. It was a casualty of the construction of the American National Insurance Company headquarters in 1971. (Courtesy Galveston County Historical Museum.)

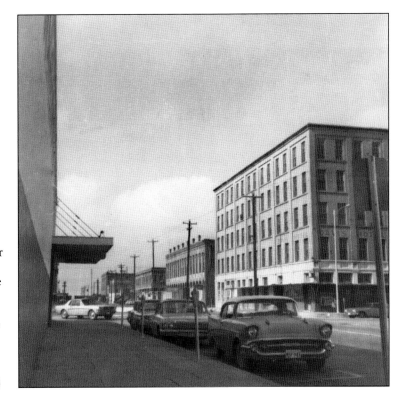

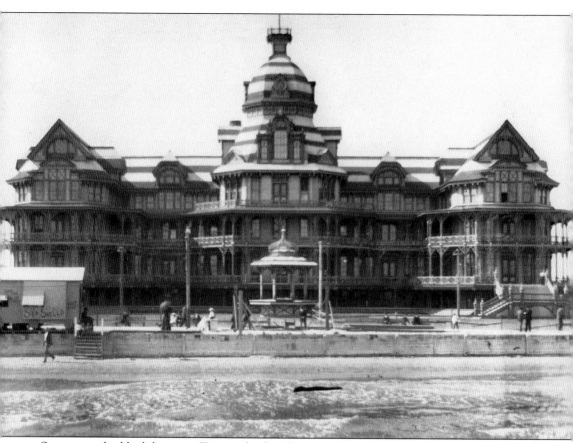

Occupying the block between Twenty-third and Twenty-fourth Streets and Avenues Q and R, the Beach Hotel offered 119 guest rooms, a billiards hall, a bar, and a large dining room on the second floor, under the octagonal dome. The Pagoda Bathhouse was located directly in front of the hotel, along with several lunch and curio stands and a small breakwater. A bandstand provided entertainment to guests, who could listen from the verandas. The hotel was the setting for Pres. Benjamin Harrison's speech on April 18, 1891, where he addressed the benefits of the federal involvement with deep-water port projects and the benefits anticipated by the quick completion of the Nicaragua canal. The former location of the hotel is now the beach and Seawall Boulevard at the Twenty-fourth Street jetty. (Courtesy Galveston County Historical Museum.)

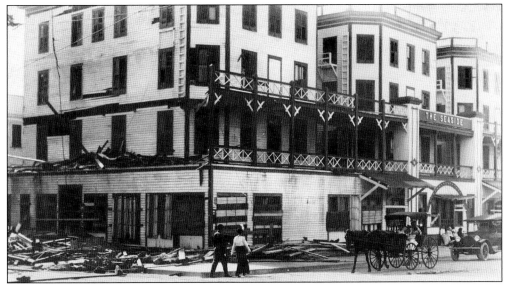

The Seaside Hotel opened on May 25, 1907, at 2021 Tremont Street, at the northwest corner of Twenty-third Street and Avenue Q. Automobiles made the beach more accessible to the public and increased Galveston's popularity as a beach resort. This hotel and rooming house offered 77 rooms near the surf. A fire in the early morning hours of December 8, 1917, destroyed this structure and the adjacent Gulf View Hotel. (Courtesy Galveston County Historical Museum.)

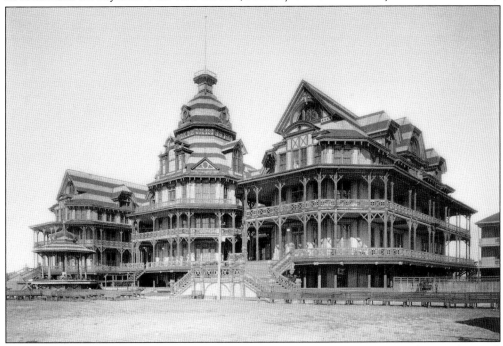

The Galveston Railway Company commissioned Nicholas Clayton to design the Beach Hotel, which opened on July 4, 1883. Just 12 years later, the structure had deteriorated to the point where it was declared a fire hazard. Sold in 1896 at a sheriff's sale, Clayton oversaw a remodeling of the building, including painting the exterior brilliant carmine, olive, and extra-pale green. It was destroyed in a suspected arson fire on July 23, 1898.

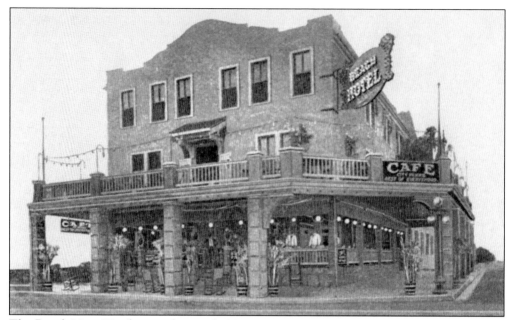

The Beach View Hotel opened around 1908 at 2202 Avenue Q and, within a few years, was known as the Beach Hotel. A fire, which started from an overheated gas stove on the third floor, destroyed the structure on December 4, 1945. It was replaced by the Beach Hotel Apartments, Milton's Turkish Baths, and the Beach Amusement Parlor.

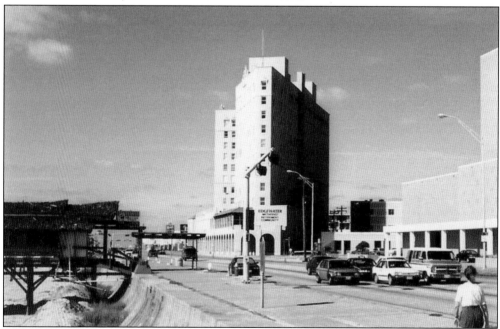

W. L. Moody Jr. commissioned Andrew Fraser to design the 11-story Buccaneer Hotel at the northeast corner of Twenty-third Street and Seawall Boulevard in 1929. It was used as a retirement home from 1962 until it was imploded on January 1, 1999. George L. Dahl's convention center (at right) lasted from 1957 until 2005. The legendary Balinese Room (left), listed on the National Register of Historic Places, was destroyed by Hurricane Ike on September 13, 2008.

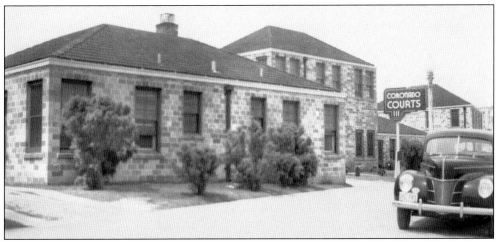

W. L. Moody Jr. commissioned Andrew Fraser to design the Coronado Courts Tourist Camp, which opened in May 1936 to much fanfare. Located along Seawall Boulevard between Twenty-sixth and Twenty-seventh Streets, it incorporated a drugstore at its southeast corner. It served as a popular destination for school groups visiting the island. It became known as the Nautilus Motel in 1963 before being demolished in September 1970 for a new motel.

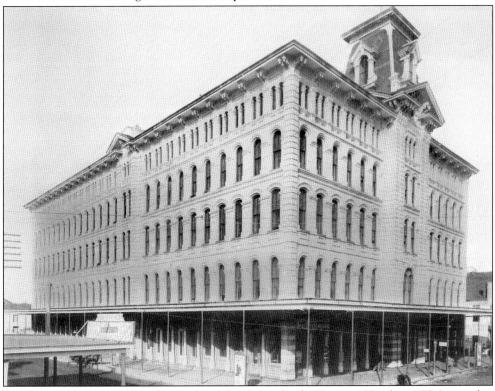

The firm of Clayton and Lynch completed the design for the Tremont Hotel in 1877. Located at the northwest corner of Tremont and Church Streets, it replaced a structure destroyed by fire on July 21, 1865. The center of business and society functions for many years, the hotel was demolished in 1928. The site served as a car lot and gas station until the City National Bank constructed a building on the site in 1952.

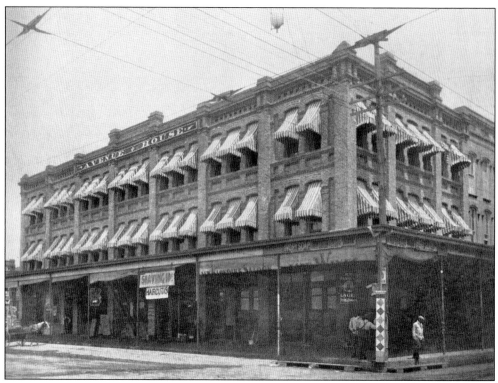

The Avenue House Hotel was constructed in the 1890s at the northeast corner of Twenty-Fifth and Market Streets. By 1948, it was known as the Central Hotel. It was the Stella Maris Apartments when eight people were killed in a fire on April 19, 1977, which destroyed the building. This prompted the city to set standards for the minimum number of firefighters responding to a call.

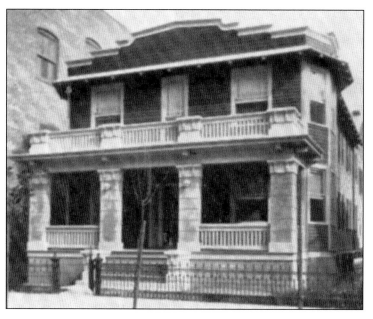

The St. Charles Hotel, at 2309 Church Street, served the downtown business district from 1909 until 1960. An early advertisement boasts rooms—single or en suite, and American (includes breakfast) or European (room only) plans. The hotel was demolished in June 1960, when the contractor offered materials for sale, including a fire escape, 150 standard doors, and all types of long leaf yellow pine.

Two

RESIDENCES

Alfred Muller designed this mansion for his uncle, Herman Marwitz, at 803 Twenty-second Street in 1894. Construction depleted the finances of Marwitz, who was involved in ship chandlery, railroads, and banking. The structure served briefly as the Goldbeck College of Music, a boardinghouse, and a "house of ill repute" before the First Baptist Church purchased it in 1931. Known as "Old Castle," the building served as a Sunday school until being demolished in 1969 for a parking lot. (Courtesy HABS.)

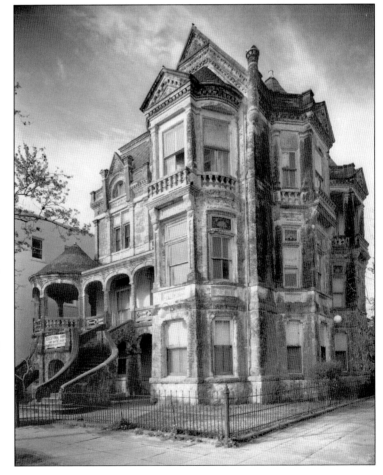

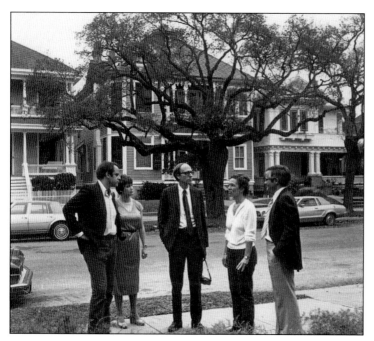

Morris J. Sass built this residence (behind the tree) at 1616 Sealy Street in the mid-1890s. Sass was a partner in the Island City Manufacturing Company, cotton factors and manufacturers of clothing. Featured in this photograph are Arthur P. Zeigler Jr. (center) and Peter Brink (far right), two national leaders in the historic preservation movement. The Sass residence was an apartment for college students when it burned on September 24, 1981.

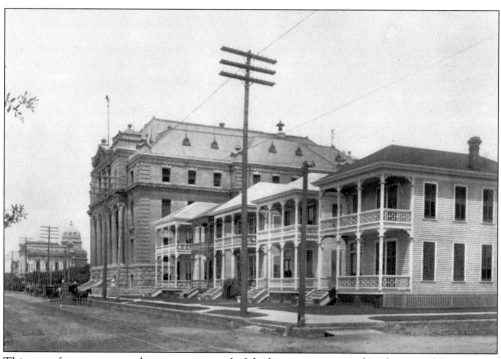

This row of two-story townhouses was typical of the homes constructed in the years following the 1885 fire. Many of them offered rooms for rent, no doubt serving the nearby Galveston County Courthouse. Over the years, the courthouse facility grew, and this row was demolished. The county closed this section of Ball Avenue in 1988 to construct a parking garage, further interrupting the grid of streets in the central business district.

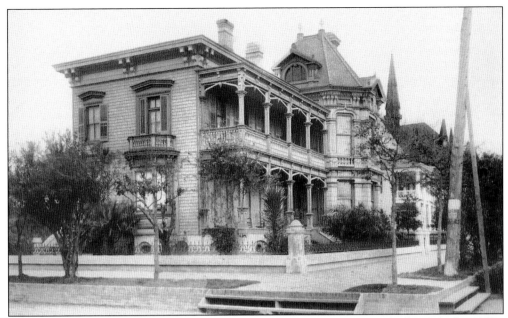

The original residence constructed at 822 Tremont Street for John Sealy dated to the 1850s. Sealy was involved in the mercantile business, banking, and railroads, and was a founding partner in the Galveston Wharf Company in 1854. Additions in the 1890s and in 1914 altered the look of the original house. It was demolished in June 1956 for a new sanctuary for the First Baptist Church.

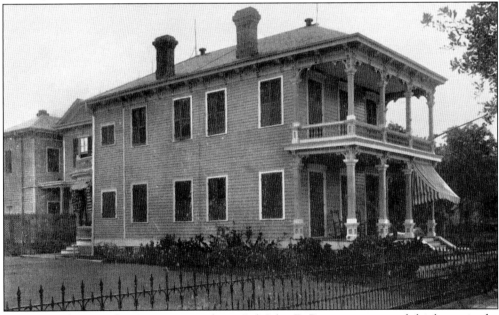

The cotton factor and commission merchant Col. John D. Rogers constructed this house in the 1870s at 903 Twenty-third Street. He was a member of Company H, Hood's Texas Brigade of the Army of Northern Virginia and was present at the surrender at the Appomattox Courthouse. The residence was occupied by his son and family until being demolished in the early 1950s to provide parking for the nearby Sears, Roebuck, and Company.

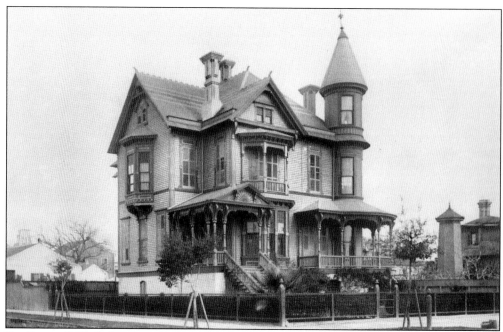

Dr. George P. Hall, doctor and lecturer on diseases of the ear, nose, and throat at the University of Texas Medical Department, built this house at 2328 Sealy Street around 1890. By 1902, Dr. Hall had moved to Houston to start a practice there, and his former residence became a boardinghouse. It was demolished in the mid-1950s and became the site of an addition to the Rosenberg Library in 1971.

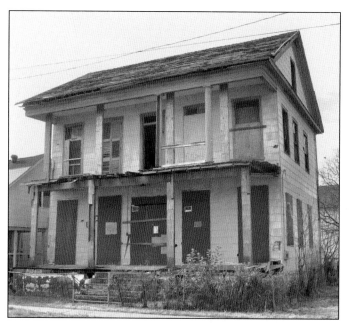

Galveston's 1885 bird's-eye map shows 2627 Ball Street, which may have dated from an earlier time, considering Galveston's history of moving houses. Inhabitants included James H. Gibson, furniture mover; Rebecca and Alf Ailes, longshoreman for the Southern Pacific Steam Ship Line; and Hattie and Jack B. Fields, bricklayer. After a small fire and many years of vacancy, the City of Galveston demolished the building in 2009, citing code violations.

Gustav H. Mensing was a partner in Mensing Brothers and Company, which operated a wholesale grocery and cotton brokerage business. He built this house, located at the southwest corner of Ball and Nineteenth Streets, in 1886. Mensing's daughter, Ella, was married to John Scofield Hershey in the house in 1909 and lived there for the next 50 years. The building was demolished in the 1960s.

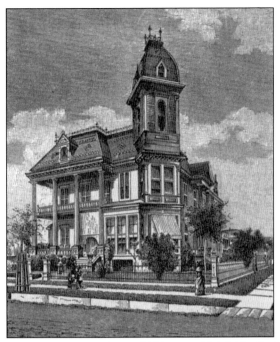

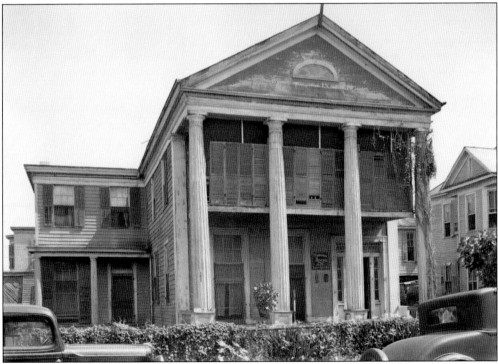

The Allen Lewis House was constructed in the 1840s and was moved in 1869 from 2501 Broadway Street to make way for St. John's Church. Lewis was lost at sea during a hurricane that year while returning from New York City with furnishings for the new church. By 1936, when the residence was recorded by the Historic American Building Survey, it was a second-rate boardinghouse at 2328 Winnie Street. The structure was demolished in February 1948. (Courtesy HABS.)

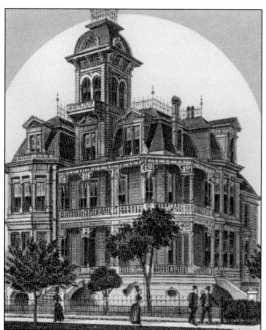

One of the city's most prominent real estate agents of the late 19th century was Henry Trueheart of Trueheart and Adriance Company. He participated in the Battle of Galveston on January 1, 1863, and was later the Galveston County tax assessor and collector. Nicholas Clayton completed this residence for him in 1886 at 1606 Broadway Street. The building survived until 1929, when his daughter, Sally Trueheart Williams, built a smaller house in the side yard.

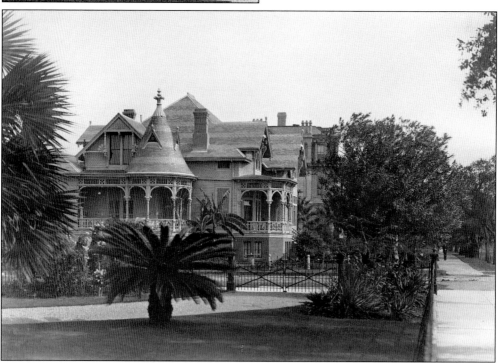

Nicholas Clayton completed this house in 1888 for Nathaniel H. Ricker at 1628 Broadway Street. Ricker was a partner in the railroad, street, and general construction firm of Ricker, Lee, and Company. It was later home to Heinrich Mosle, a grocer, commission merchant, and ship agent who served as consul for Costa Rica and vice-consul for Spain. The Broadway Church of Christ purchased the structure in 1946 and demolished it in April 1958 to build a new sanctuary. (Courtesy Galveston County Historical Museum.)

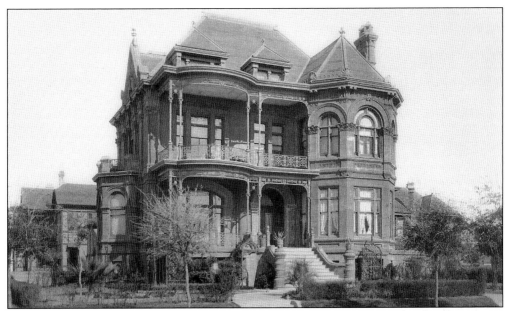

Nicholas Clayton designed this residence for the German-born financier and real estate investor Morris Lasker at 1726 Broadway Avenue. Lasker established the Texas Star Flour Mill and, in 1912, gave funds for the remodel and expansion of the orphanage at 1019 Sixteenth Street. His residence was constructed from 1889 to 1892 and was demolished in 1967 to build several condominiums. The Texas Red granite carriage step still remains along Broadway Avenue.

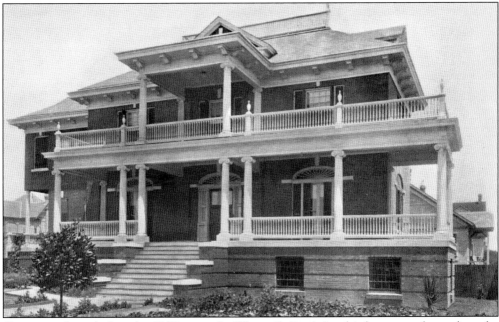

Constructed just before the 1900 storm for Waters S. Davis Jr., this house was located on the northwest corner of Nineteenth Street and Broadway Avenue. Davis was a partner in the firm of Davis and Randall, an exporter in cotton seed products, as well as president and general manager of the Seaboard Rice Milling Company. The structure was converted into apartments by the late 1920s and was demolished around 1970 to build the Broadway Service Center gas station.

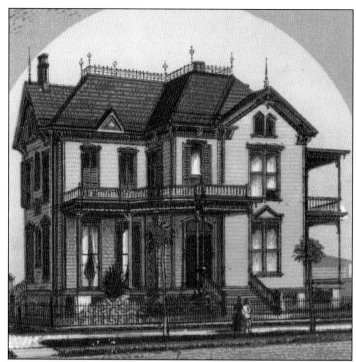

The residence of Francis L. Lee, a partner in the railroad and general contracting firm of Ricker, Lee, and Company, was located at 1926 Broadway Avenue. The home was later owned by real estate agent David Fahey. A 1936 newspaper advertisement offered "two full lots and improvements to be sold," and by 1946, the structure was replaced by a gas station.

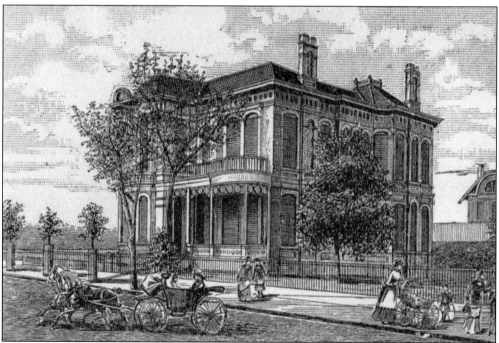

Nicholas Clayton designed the residence at 1526 Postoffice Street for Bertrand Adoue. The structure was completed in 1882. Adoue was prominent in banking and numerous industrial interests of the city and served as the vice-consul for Sweden and Norway. The Dominican Order acquired the house in 1927 as a high school for girls. The building served as the music hall for Sacred Heart Academy during the 1940s until being demolished for a new convent around 1949.

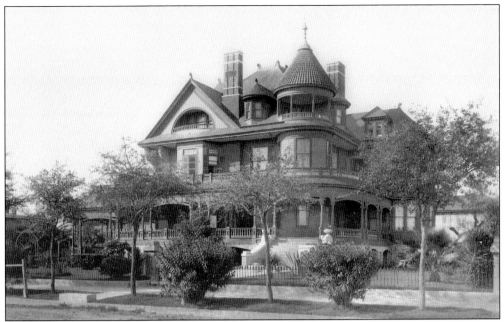

Peter J. Willis Jr. built this residence in 1889 at the northwest corner of Twenty-third Street and Broadway Avenue. Willis was the owner of a cotton factor, wholesale grocer, and commission merchant firm, as well as president of the Galveston Export Commission Company. The home was later sold to Mattie C. Wren, who operated an upscale guest house. The structure was replaced by a Firestone Tire and Rubber Company service station in 1940.

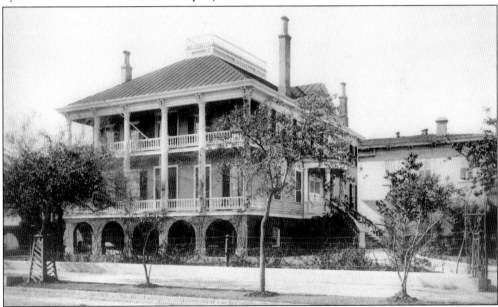

Jacob L. Briggs constructed a residence on the southwest corner of Broadway Avenue and Twenty-third Street in the 1840s. This house was purchased in 1870 by the cotton magnate William F. Ladd, who made substantial additions. It was later home to the Artillery Club and, in 1946, was moved south of the alley to be used as the headquarters for Veterans of Foreign Wars. A gas station then occupied the site.

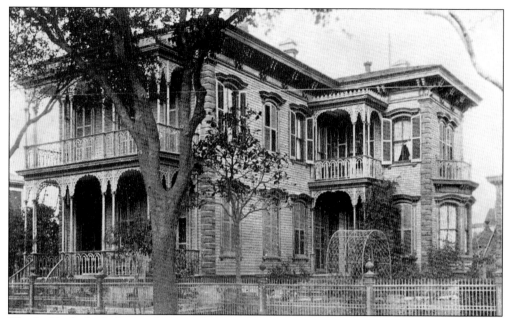

Charles Fowler built this residence at the northwest corner of Broadway Avenue and Twenty-fifth Street in the 1870s. Fowler was a partner in the firm of Fowler and McVitie, steamship agents, and served as vice-consul to Sweden. He was on the deep water committee and was instrumental in the deepening of the Galveston channel. Fowler died on June 15, 1931, and the residence was demolished that November to make way for a refrigerator showroom.

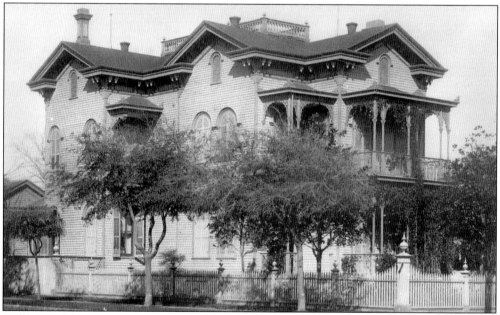

William R. Johnson, a real estate agent, U.S. commissioner, and commissioner of deeds, built this house at the northeast corner of Twenty-sixth Street and Broadway Avenue by 1885. It was later owned by Ella and Harry A. Black, president of the Black Hardware Company. The Prudential Insurance Company owned the property for several years before the structure was demolished in the 1960s to be replaced by a Dairy Queen.

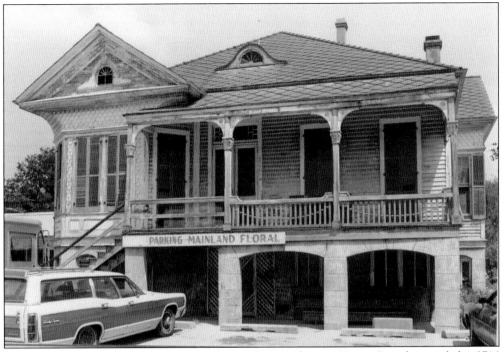

Emelie Girardin, widow of prominent Galveston liquor salesman Victor Girardin, resided at 2716 Broadway Avenue from the 1890s through the 1910s. In the mid-20th century, Elizabeth McCarthy, widow of the banker Edward McCarthy Jr., lived here. The house was demolished around 1977 to provide parking for the Mainland Floral Shop next door.

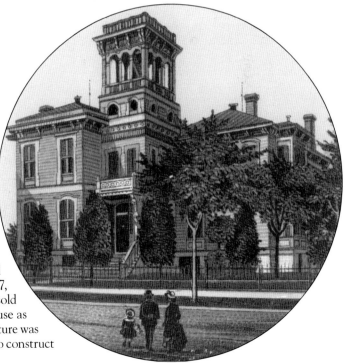

The residence of Capt. Robert Irvine, at 3425 Broadway Avenue, appears on the 1885 bird's-eye map of the city. The captain formed a ship agents and commission merchants partnership with Charles Beissner in 1880 as Irvine and Beissner. Irvine died in 1897, and the house was eventually sold by Maco Stewart in 1910 for use as St. Patrick's School. The structure was demolished in the mid-1920s to construct a new school building.

It has been common in Galveston for property owners to construct two or three houses of similar form next to each other for use as rental property. This appears to be the case with 3606 (left) and 3602 Broadway Avenue, as well as 3608 (below) and 3612 Broadway Avenue (opposite). These four structures were demolished in the late 1970s and early 1980s to be replaced by commercial buildings similar to those in most towns across the country.

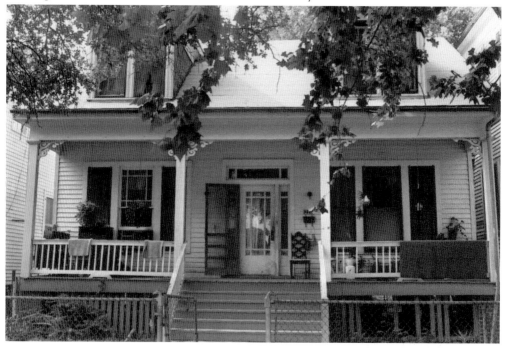

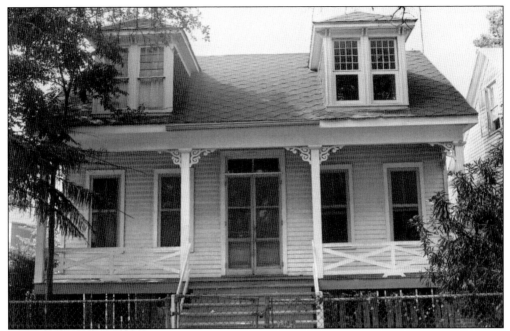

This house at 3612 Broadway Avenue served as the residence of painters and workers in the nearby wharves and shipyards. The family of Gould McCoy, an engineer for the G&H Towing Company, occupied the house from the 1940s through the 1970s. From this porch the effects of the automobile on Galveston's main street could be seen. Many residences along the boulevard were replaced with gas stations, fast food restaurants, and commercial buildings.

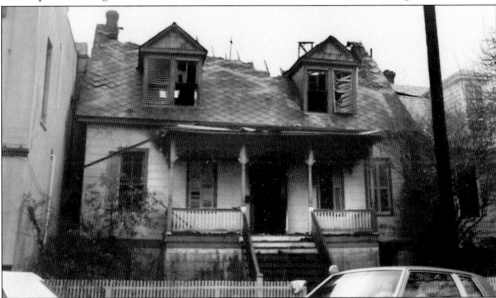

Henry D. Schutte operated a corner grocery at 801 Postoffice Street and lived upstairs at that location before purchasing the house next door at 805 Postoffice Street from the estate of Capt. Peter McKenzie in 1909. The Schutte family owned the house for more than 50 years until it was sold in 1964 to become the Williamson Rooming House. A fire started in the kitchen of one apartment on February 7, 1992, destroying the building.

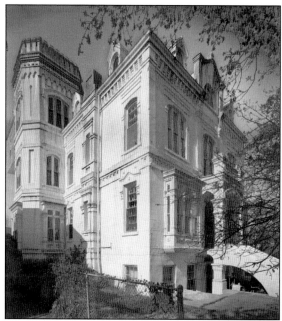

The residence commonly known as Heidenheimer Castle was constructed for Mayor John Syndor in 1857. Nicholas Clayton was hired to remodel and expand the residence in 1888 for the wholesale grocer Sampson Heidenheimer. This structure at 1602 Sealy Street sustained heavy damage during a fire in November 1973 and was demolished in 1975. (Courtesy HABS.)

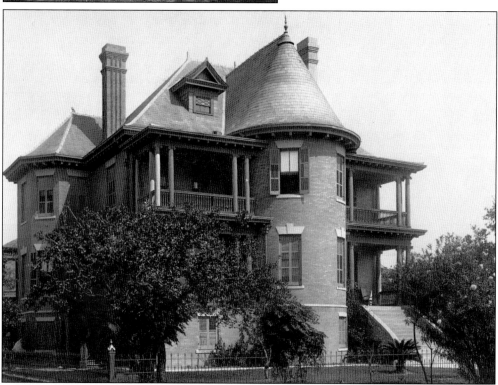

In 1897, George B. Stowe designed this residence at 1426 Postoffice Street for Charles L. Wallis, first vice president of the Galveston Fruit Importing and Trading Company. Similar to many of the larger houses near the University of Texas Medical School, the structure served as a fraternity house during the mid-20th century. Alpha Kappa Kappa moved out in 1965, and an apartment block replaced this building. (Courtesy Galveston County Historical Museum.)

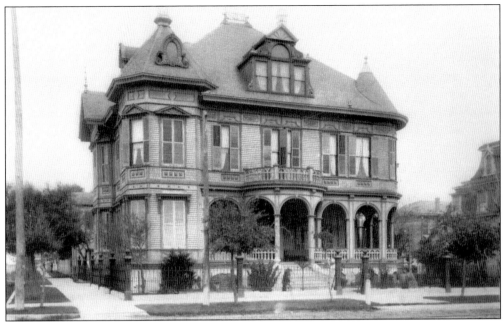

This house, at 1228 Market Street, was built for John Focke of Focke, Wilkens, and Lange. Along with Henry Wilkens and Herman C. Lange, Focke served as a wholesale grocery and liquor dealer, importer, cotton factor, and commission merchant. Members of the Focke family lived here until 1923. The structure later became a fraternity house for Alpha Mu Pi Omega and then Phi Beta Pi before being demolished in April 1956.

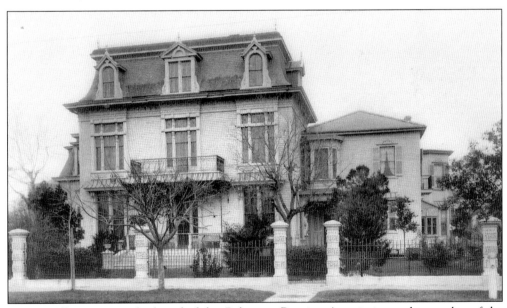

Henry Wilkens was on the board of the Galveston Brewing Association and a member of the Galveston Cotton Exchange and Board of Trade. Born in Bremen, Germany, in 1841, Wilkens moved to Galveston during the Civil War and constructed this residence at 1212 Market Street by 1893. An advertisement from the summer of 1935 shows the house was being demolished and advertised lumber, doors, windows, pipe, iron fence, heaters, brick, and fancy trim for sale.

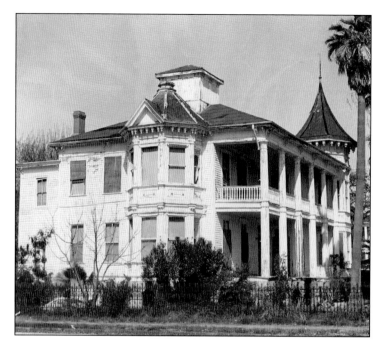

All that remains of the John L. Darragh House at the northwest corner of Fifteenth and Church Streets is the impressive fence that surrounds the property. Darragh was president of the Galveston Wharf Company when his wife commissioned two smaller houses to be moved together in 1886. The Galveston Historical Foundation sold the property, and renovations were about to begin when an arsonist destroyed the building on November 8, 1990.

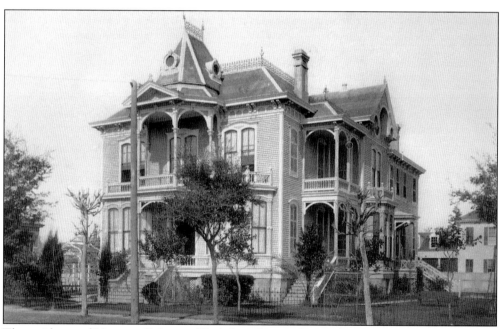

The residence of Herman C. Lange filled three lots at the northwest corner of Eleventh and Winnie Streets, across from the original Rosenberg Elementary building. Lange was a partner in the wholesale grocery, importer, cotton factor, and commission merchant firm of Focke, Wilke, and Lange. The residence was advertised for sale in 1939 and was demolished shortly thereafter for the construction of several smaller residences.

During the early hours of Friday, November 13, 1885, a fire began at the Vulcan Foundry and destroyed 43 blocks as it traveled south. In its aftermath, this residence was constructed at 509 Nineteenth Street for Peter H. and Elizabeth Moser. A punched metal soffit featuring lyres and urns crowned the stately building. Fire destroyed the building as Hurricane Ike prepared to make a direct hit on the city on September 13, 2008.

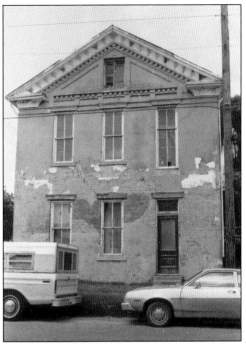

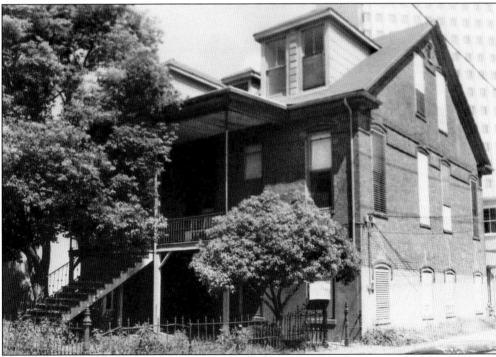

This house served as a reminder of the brick construction employed after the 1885 fire and was constructed for the bookkeeper James S. DeForest in 1890. In November 1911, Alfred S. Newson, proprietor of the Model Meat Market, sold it to William Lawes, a carpenter, builder, and manufacturer of ice chests and refrigerators. The cottage was destroyed by fire as Hurricane Rita passed to the east of the island on September 23, 2005.

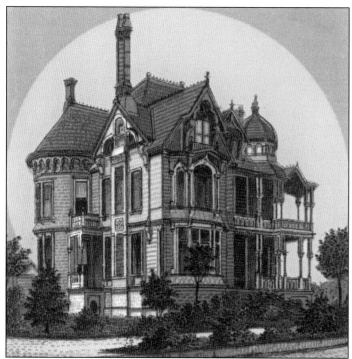

In 1888, Nicholas Clayton completed this residence at 1220 Ball Street for George Seeligson, vice president of the Galveston Dry Goods Company. On June 17, 1895, nineteen local women met here as the guest of Mrs. Seeligson to form Texas's first chapter of the Daughters of the American Revolution (George Washington chapter) on the anniversary of the Battle of Bunker Hill. The house was demolished in 1934, but the stable was spared.

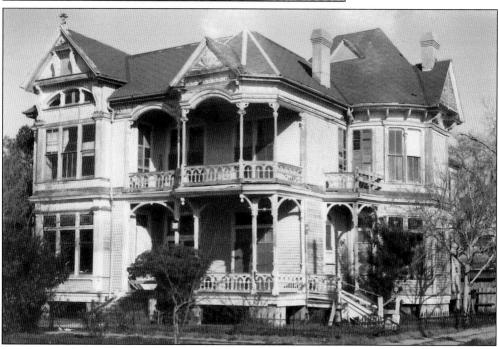

Caroline Block was the widow of Jacob Block, a partner in the dry-goods firm of Greenleve, Block, and Company. Constructed in 1886, this residence at 1804 Ball Street was later owned by Mamie and Robert Weis, president of the Galveston Dry Goods Company. Having no children, they left the bulk of their estate to the school district to establish a high school named after them. The house was demolished in May 1967.

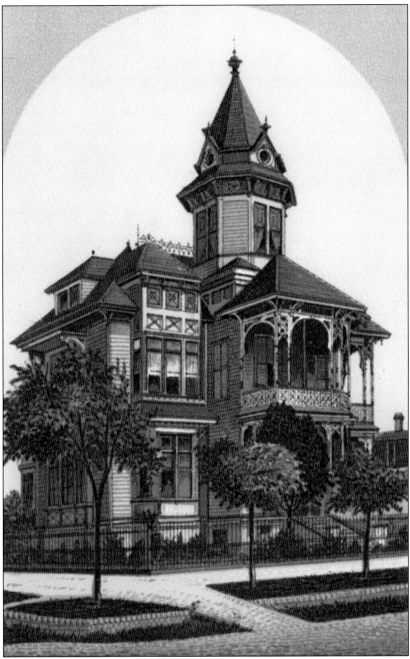

Built for the cotton and insurance man C. G. Wells, this residence at 1528 Sealy Street was purchased in 1886 by Harris Kempner. Kempner was involved in the wholesale grocery, cotton, banking, and railroad businesses. He was born in Poland in 1837 and moved to Galveston from Cold Springs, Texas, in 1870. He was a partner in the wholesale grocery firm of Marx and Kempner and served on many boards, including as director of the Bluefields Banana Company at the time of his death in 1894. The philanthropic nature of Kempner is continued by his family today. The building served as the Phi Beta Pi fraternity house and was a rooming house before being demolished in the fall of 1951 to construct apartments.

This small raised cottage at 1103 Avenue K was typical of the commissary houses built immediately after the 1900 storm to shelter families whose homes were destroyed. It was occupied by many working-class families, including a painter, a carpenter, a cook, and a cotton warehouse worker. The Galveston Historical Foundation moved a similar house damaged by Hurricane Ike from 1207 Twelfth Street in January 2010 to save it from demolition.

The house at 1110 Fifteenth Street was constructed around 1892 for John Wegner, who owned a grocery, liquor, and feed business at 1921 Market Street with his brother, Ernst. It remained in the family through the 1930s. In the 1950s, it was occupied by Gladiola Gonzales, a meat wrapper at Henke and Pillot Grocers on Tremont Street. The Gonzales family continued to own the house until it was demolished around 1990.

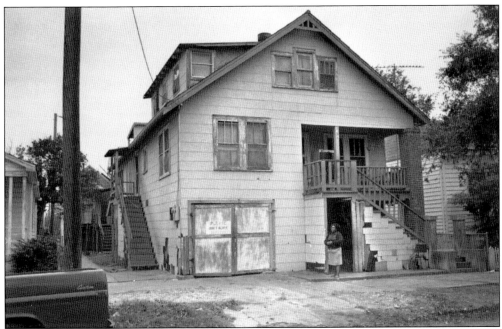

This craftsman-style raised cottage, located at 1317 Avenue K, was occupied in the 1910s by J. William Aarts, a local bartender. Later inhabitants included Sarah and Jacob Kelner, a peddler, and Marie and W. Earl Byous, a projectionist at the Isle Theater at 2110 Market Street (also demolished). During the 1950s, the house was divided into apartments and survived into the 1980s.

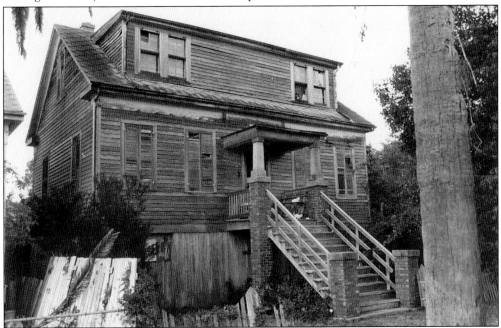

The house at 1512 Avenue L was built in the 1850s on what was then the edge of town. In 1914, it was home to John Jacobs, a fireman, and William Connorty, a railroad brakeman. By the 1940s, it was owned by the H. Frederick Hoelter family. Two of Frederick's daughters lived in the house until fire broke out on January 17, 1990. City officials called for the demolition of the remaining structure.

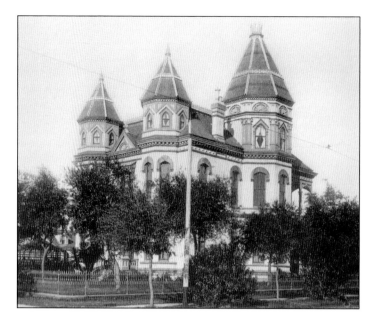

The hardware merchant E. S. Woods commissioned Edward J. Duhamel to design this residence at 1120 Tremont Street in 1877. It was later owned by Alphonse Kenison, a lumber and commission merchant and insurance agent. Maco Stewart Sr. owned the house when it was heavily damaged in the hurricane of 1943. The property was sold, and house was demolished to provide a parking lot until a new YMCA facility was constructed in 1950.

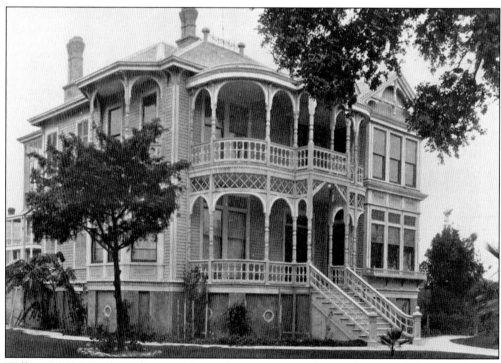

William McVitie built this house at the southwest corner of Tremont Street and Avenue M in the 1890s. He was a partner in the firm of Fowler and McVitie, wholesale dealers in coal, construction, and shipping supplies. Jessie Barbour McVitie willed the house to Trinity Episcopal in 1940, and the building was a rectory until being sold to Pennington Buick in October 1950. Ben Milam designed an automobile showroom that replace the house that year.

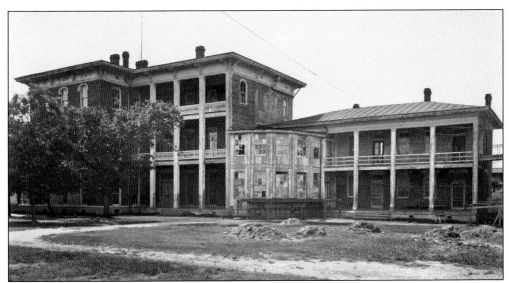

Similar in age and style to Ashton Villa, this residence was constructed in the late 1850s for Thomas M. League. Col. J. D. Waters, a Brazos River planter, purchased the house in the late 1860s and operated it as a prominent hotel and boardinghouse. Later owned by Col. W. L. Moody, the structure was purchased on September 8, 1927, when Kirwin High School was established. It was demolished in 1941 after a new school building was constructed. (Courtesy HABS.)

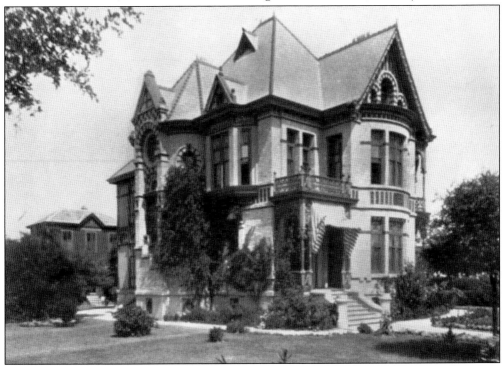

Nicholas Clayton designed a house for Galveston lawyer John W. Harris during the mid-1870s at Forty-first Street and Avenue R. Clayton was hired again to design this residence at 1404 Tremont Street in 1890. Clayton also oversaw repairs to the house after the 1900 storm. Kirwin High School acquired the house in the late 1920s and demolished it in 1941.

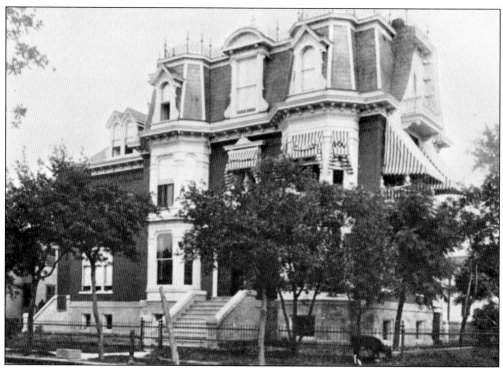

Capt. William Bradbury constructed this house at 2425 Avenue K around 1858. Joseph Seinsheimer purchased the home in 1883 and had the brick structure raised 5 feet in the years just prior to the 1900 storm. Seinsheimer was the manager for the banking and cotton interests of Harris Kempner. In 1978, the house was demolished and replaced by an office building.

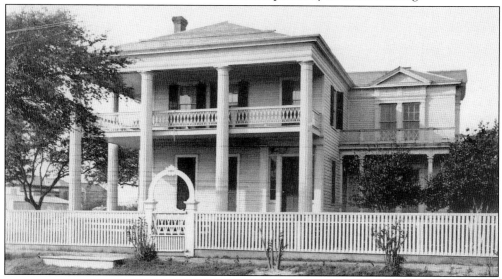

The prominent lawyer Leo N. Levi lived in this house at the southwest corner of Thirty-first Street and Avenue O. He resided in Galveston from 1876 to 1899 and, the following year, was elected president of the Independent Order of B'nai B'rith. He served as an advisor to Pres. Theodore Roosevelt on Jewish policy and wrote the Kishineff Petition after a Russian anti-Semitic massacre in 1903.

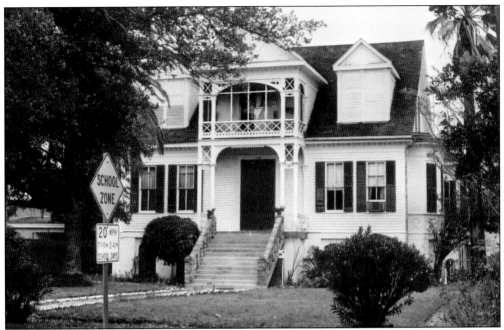

This residence at 3123 Avenue N was built in 1883 for Henry Cortes, a real estate investor and manufacturer of soda, sarsaparilla, and ginger ale. Around 1910, the home was owned by Charles J. Michaelis, co-owner of the Ineeda Drug Store at 2223 Market Street. The house sat vacant for several years before burning at the hands of an arsonist in the early morning hours of April 28, 2000.

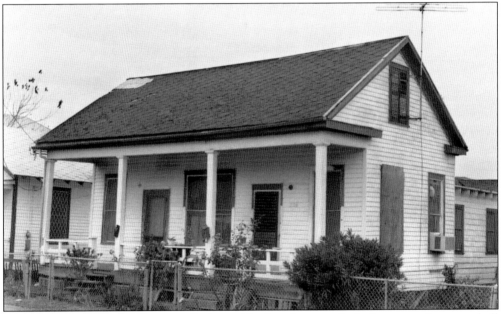

This small house in the Kempner Park neighborhood was typical of many early center-hall homes. Additions were made toward the alley and windows, and doors were swapped to convert it into a duplex. It served as home to many laborers and longshoremen during its life before being demolished in 1978 by the City of Galveston for code violations.

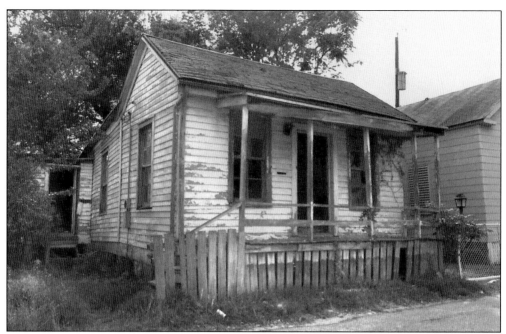

Galveston's smaller houses tell the story of the working class and often immigrant families that helped the city prosper. This house at 1310 Thirty-second Street was constructed around 1885. In the 1930s, it was home to Rosie and Adm. D. Love, a longshoreman for the Southern Pacific Steam Ship Line. Rosie L. Love, who worked at the Turf Grill, lived here for nearly 30 years. The home was demolished in the mid-1990s.

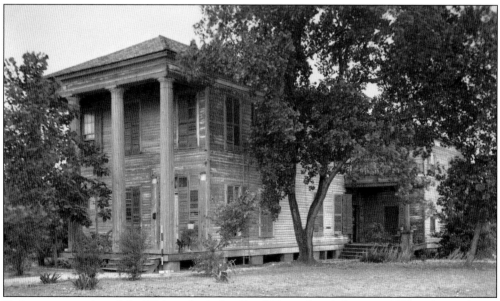

Early cotton merchant John Wolston built this Greek Revival–style house in 1859 at the southwest corner of Thirty-fifth Street and Avenue O. Wolston was a partner in the firm of Wolston, Wells, and Vidor, along with C. G. Wells and Charles Vidor, grandfather to the acclaimed film director King Vidor, who was born in Galveston. Wolston's residence was demolished in 1936 to make way for the Windsor Court Apartments. (Courtesy HABS.)

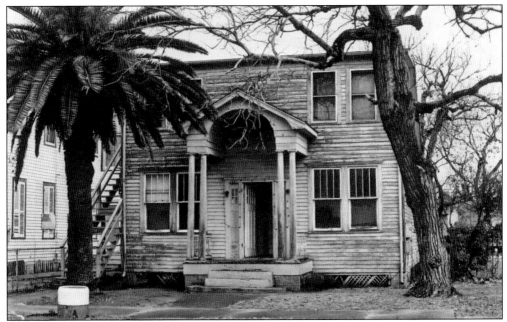

This house with its oversized entry porch was located at 3506 Avenue O, next to the Thomas Jefferson League House (now demolished). Inhabitants included Francis B. Butler, a carpenter; Agnes and Bryant J. Ewing, manager of the Sinclair Refining Company; Viola and Elvin M. Pool, watchman at the Todd Shipyard; and Charles Lewis, a city employee. The structure was demolished in the early 1980s.

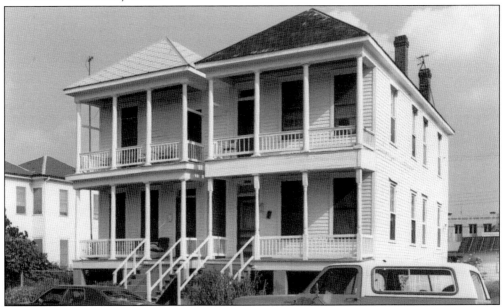

A building permit was issued in November 1907 for a frame addition to the house at 2514 Ball Avenue. Louis M. Mornier, the owner, was a marine engineer for Charles Clarke and Company. Subsequent owners included Texana and Arthur Rogers, longshoreman for the Clyde-Mallory Lines, and Irene and Link Tanner, a blacksmith. The house was demolished after this photograph was taken in 1977.

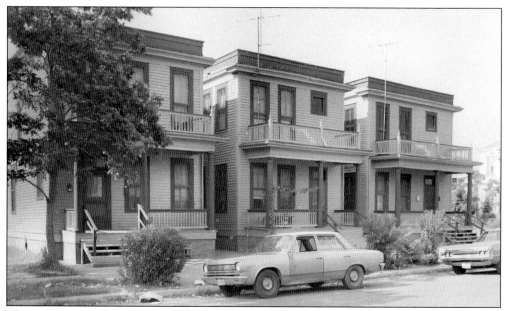

These three rent houses were constructed at 2621, 2625, and 2627 Sealy Street in the years following the 1900 storm. Inhabitants ranged from engineers, clerks, and janitors for the Gulf, Colorado, and Santa Fe Railroad, to salesmen and longshoremen. Architectural historian Ellen Beasley surveyed the Old Central and Carver Park neighborhoods in 1977. Within eight years of this photograph, these houses were demolished.

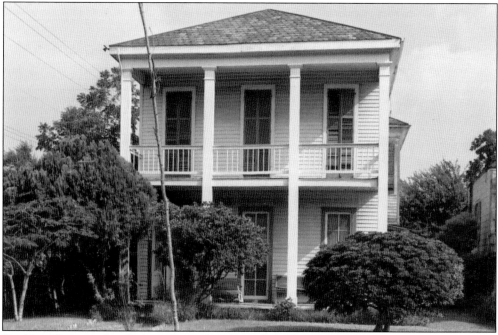

Double galleries and walk-through windows graced the front of this house, built in 1882 on the northeast corner of Twenty-seventh and Sealy Streets. An addition was added on the residence the following year. In 1914, it was home to Frederick Gherbis, a bartender at Coselli and Da Valle's Saloon. The home was razed in October 1992 after sitting vacant for years.

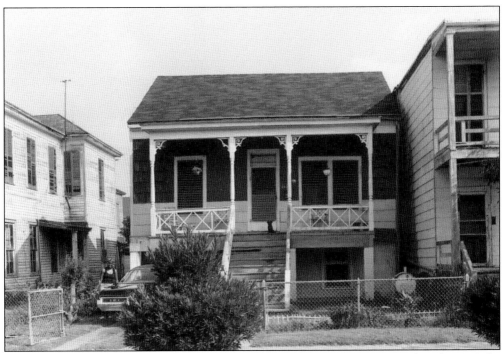

Continuing east to 2624 Sealy Avenue was the modest raised cottage occupied in the 1910s by Morris Haar, a huckster or peddler of small items. During the 1930s and 1940s, Amelia and John Wright, a barber at C. P. Johnson Barber Shop, called this home. The structure survived until around 1990.

This side-hall house at 2618 Sealy Street had its double galleries screened so its inhabitants could enjoy the gulf breezes without the bother of mosquitoes. In the 1910s, it was the home of Rev. Abraham D. Rosenblatt and the Congregation Ahavas Israel. During the 1950s, Anastacia and Lucius Francis, a cook for the Southern Pacific Line, lived here. The house was demolished in the late 1970s.

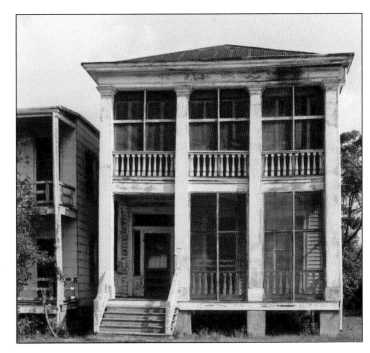

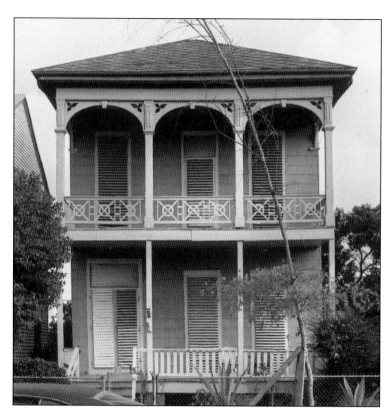

The house at 2616 Ball Street is similar to those built in the East End during the late 1880s after the 1885 fire. The first floor's side hall turned into a center hall upstairs. Although the lower rails were replaced and the facade covered with storm blinds and asbestos shingles, the form still reads through. In the 1950s, it was home to Cora and William Richardson, a longshoreman. The house was demolished around 1980.

The house at 2620 Ball Street appears on the 1871 bird's-eye map of the city, drawn by Camille N. Drie. The home's sidelights and transoms with small glass panes provide clues to its early age. This area of the city, once dense with residences, has lost thousands of buildings since the 1960s. By the 1980s, this structure was replaced by an addition to the Compton Memorial Church of God in Christ.

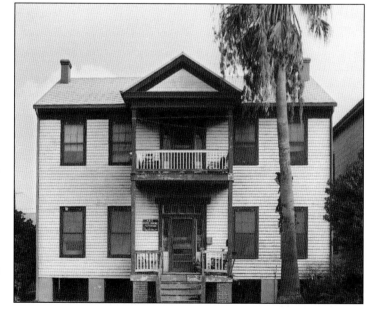

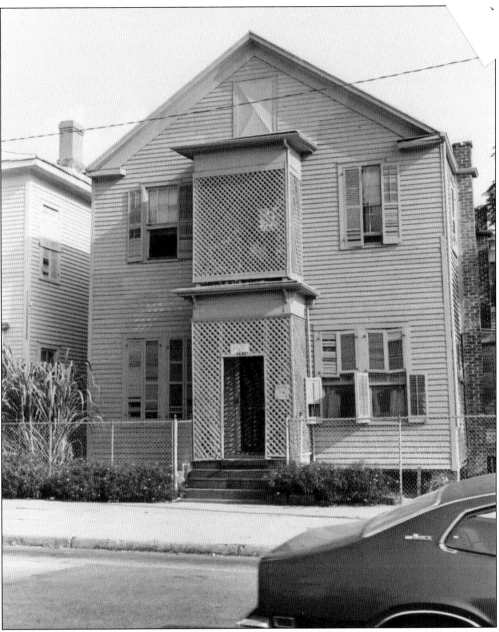

In her publication *Going Down the Line*, Mary Remmers describes the intersection of Twenty-sixth and Postoffice Streets as the center of the city's red-light district during the first half of the 20th century. She cites a 1927 study reporting an estimated "1,000 ladies of the evening, 50 bordellos and 13 other 'questionable houses' in Galveston." In June 1952, Billie Smart of 2626 Postoffice Street was convicted by a federal jury of three counts of transporting girls from Louisiana for prostitution and given a 45-month sentence and a $2,000 fine. This trial shed light on the inner workings of a brothel. Many of the brothels placed lattice around the front porch to screen guests from street view. Remmers noted that the business at this location was run by "Gouch-Eye" Mary Russell and her husband as part of a statewide syndicate, including the famous Chicken Ranch in LaGrange. The building was demolished around 2000.

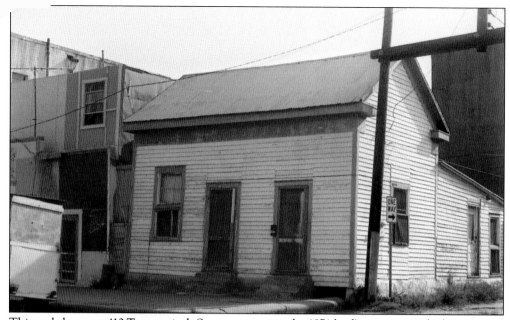

This early house at 410 Twenty-sixth Street appears on the 1871 bird's-eye map in the busy central business district within walking distance of the wharves. In the segregated 1930s and 1940s, it was a dry cleaners for African American families. Later house was the home of Bertield and Alphonse Knox, a construction worker. The structure was demolished by the mid-1980s.

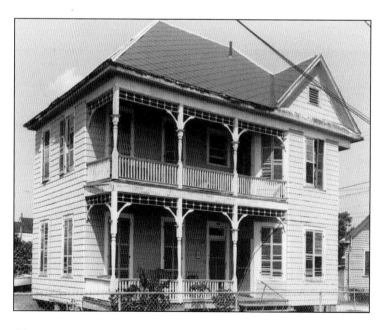

The large house at 313 Twenty-seventh Street was built around 1890 and, as with many larger homes in this area of town, was converted to a boardinghouse. In the 1910s, Gerdes Benard offered furnished rooms. In the 1950s, the building housed Ruth Mason ran Missy's Place beer hall. The structure was demolished in the late 1970s.

Little is known about this raised cottage, but the style of construction dates it to the 1890s. A shed roof addition was added to the right side of 721 Twenty-seventh Street, making an unusual front porch but giving more space to sit outside in the warm summer months. By the time this photograph was taken in 1977, the house appeared abandoned and would not survive much longer.

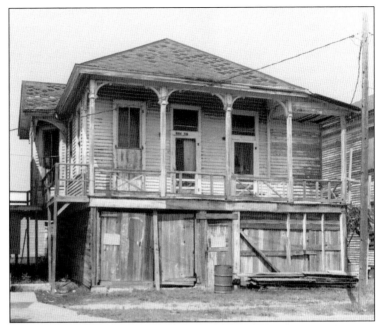

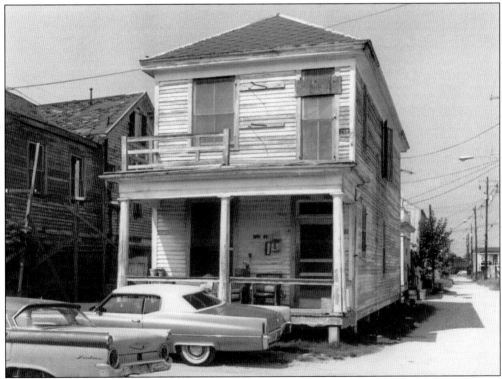

Next door sat an early boardinghouse at 713 Twenty-seventh Street, next to the infamous "Tin Can Alley," which Ellen Beasley documented in *The Alleys and Back Buildings of Galveston.* This was one of Galveston's most infamous blocks for vices ranging from prostitution and drugs, to gambling in the 19th and 20th centuries. Inhabitants of the boardinghouse included many workers on the nearby docks.

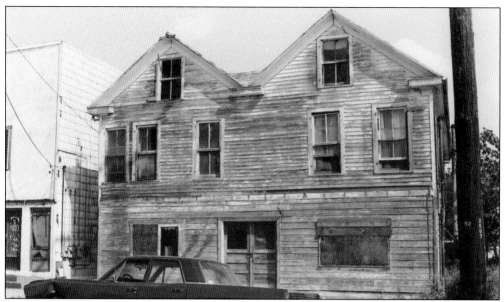

In an advertisement in the *Galveston Daily News* from 1905, real estate agent August J. Henck offered this 10-room house at 2720 Church Street with all the modern conveniences for a monthly rent of $30. By the early 1930s, the building was owned by Mae and Gus Allen, owners of the Dreamland Café at 2704 Church Street. The structure was demolished around 1980.

The house at 901 Thirty-first Street served as a rental property for years after being constructed in the 1870s, housing a carpenter, a postal carrier, and a waiter at the Hotel Galvez, among others. The author's great aunt and uncle, Myrle and Walter Davenport, an ambulance attendant and driver for J. Levy Brothers Funeral Home, lived here in 1953. The Galveston Independent School District purchased the building in 2008 and created a parking lot on the spot after allowing the Galveston Historical Foundation to salvage materials.

John H. Westerlage, a clerk with the large shipping supply firm of Fowler and McVitie, lived in this house at 3815 Sealy Street in the 1910s. This bay-front form of house was common around 1900. By the 1930s, the building was home to Sarah and William L. Black, a longshoreman for the Southern Pacific Steam Ship Lines.

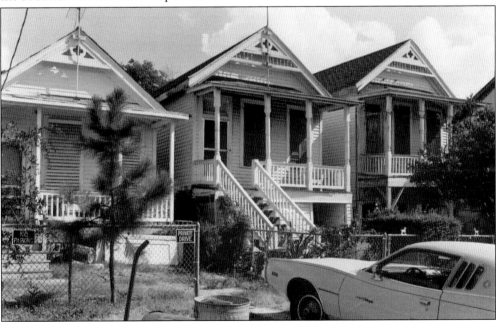

Fire insurance maps show that there were once four identical cottages on the northern side of the 4000 block of Sealy Street, constructed in the 1890s. Likely built as rent houses, the structures housed a variety of tenants, from dock workers and machinists, to custodians and students. These buildings were demolished after 1985.

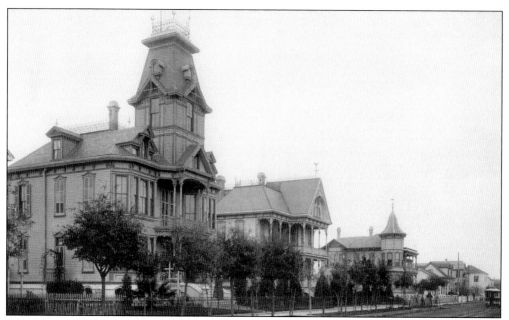

John Reymershoffer built this towered residence at 1314 Postoffice Street in 1871, and his brother, Gustav, built the house at 1302 Postoffice Street (extant) in 1887. John was president of both the Texas Star Flour Mill and the Galveston West Indies and Pan-American Company. He also served as the Austro-Hungarian consul. John's house was sold in July 1966 and was demolished to make room for five small rental houses.

Bernard Tiernan, proprietor of Two Brothers' Saloon, lived at 1501 Market Street in a house that first appears on the 1871 bird's-eye map of the city. The Tiernan family occupied the residence for more than 60 years. The family business was known as the Two Brothers' Spa during Prohibition, when it sold soft drinks at the northeast corner of Market and Twenty-third Streets. This house was demolished around 1970 for a parking lot.

It appears that the house at 1507 Market Street was moved to this location in the late 1930s, comparing the style of construction with Sanborn Fire Insurance Company maps. A *Galveston Daily News* article from March 1942 mentions that John H. Austin, a local attorney and veteran of World War I who lived here, was called back into the U.S. Army as a captain. The home was demolished around 1970 for a parking lot.

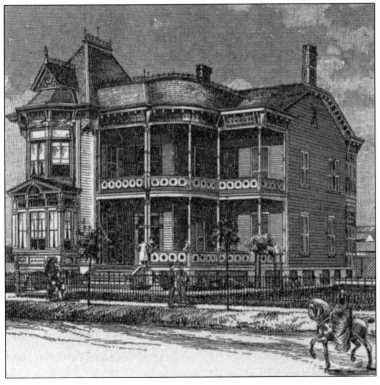

Albert Weis, treasurer and manager of the Galveston Grand Opera House Company, built this house at the northeast corner of Thirteenth Street and Broadway Avenue in the 1880s. He was one of the pioneers of the theatrical business in Galveston. The home was later occupied by the Michaels and Tartt families before being purchased by the Catholic diocese. It survived Hurricane Carla but was demolished shortly afterwards, in the early 1960s.

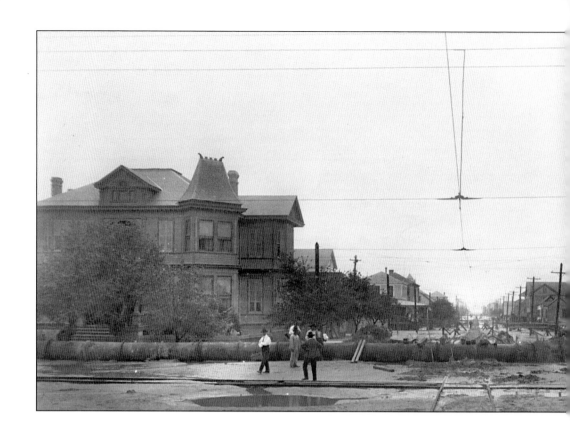

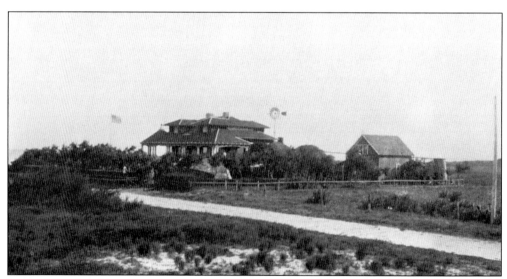

Lucien Minor's residence stood at the intersection of Fifty-fifth Street and the beach in the 1890s. Minor was a partner in the real estate firm of Trueheart and Adriance Company, treasurer of the Texas Historical Society and the South Galveston and Gulf Shore Railroad, and a member of the Texas Society of the Sons of the American Revolution. He lost his house and life in the hurricane of September 8, 1900.

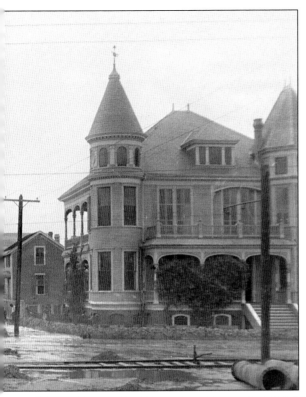

This photograph from the grade raising of Galveston was taken at Broadway Avenue looking south down Twenty-seventh Street. On the southeast corner was the residence of Edwin E. Rice, partner in the firm of Rice, Baulard, and Company, who sold paints, glass, window shades, and wall paper from their shop at 215 Tremont Street. Rice was also in the fire and accident insurance business. By the early 1920s, the house was converted to the Val-Ida Apartments. An October 1953 advertisement in the *Galveston Daily News* offered salvaged lumber, plumbing fixtures, and mantles as the house was about to meet the wrecking ball. Across the street at 2703 Broadway Avenue was the Alfred Muller–designed residence of Charles Timson. He was manager of the firm of William Cooper and Nephews of Berkhamsted, England, which manufactured Cooper's sheep dip. By the mid-1950s, the house was demolished to make way for an automobile dealership. (Courtesy Galveston County Historical Museum.)

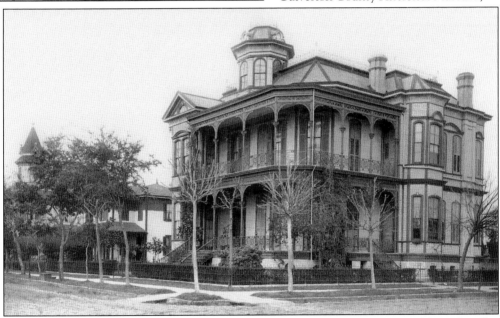

Early Texas pioneer grocer J. E. Wallis moved to Galveston after the Civil War and formed Wallis, Landes, and Company, one of the most successful merchandising firms in the South. This house was constructed in 1882 and sat one block east of the fire district. It survived at the northwest corner of Fifteenth and Sealy Streets until 1962, when the owner ordered it demolished because it was too expensive to maintain.

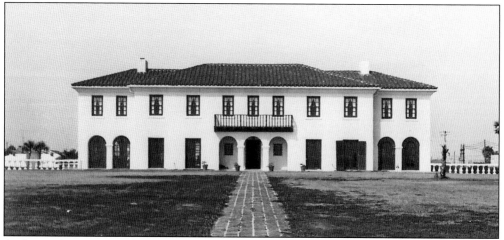

Architect Cameron Fairchild designed this house for George Sealy Jr. and Eugenia Taylor in 1931 at 5310 Seawall Boulevard. Sealy was involved in many business interests of the city, including hardware, cotton, construction, insurance, and banking. The house was demolished in December 2001 to build a volcano-shaped restaurant and amusement ride.

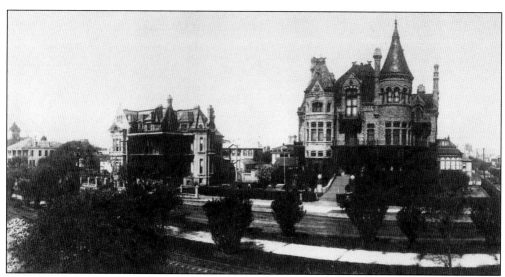

Nicholas Clayton completed this house at the northeast corner of Broadway Avenue and Fifteenth Street for the dry-goods merchant Sylvain Blum in 1885. The home was demolished in 1915 and replaced with two smaller brick residences. This photograph shows the Walter Gresham residence (right) with some original roof cresting and spire. The tower of the Sawyer-Flood House (1528 Broadway Avenue, demolished in 1965) can be seen at the far left. (Courtesy Eloise Powell.)

74

Three

SCHOOLS AND CHURCHES

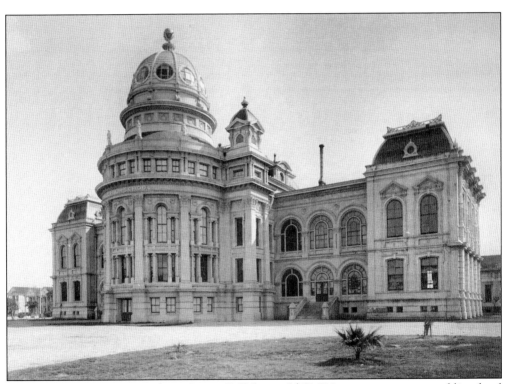

Banker and commission merchant George Ball donated $50,000 to construct a new public school building at 2114 Ball Avenue. Architect Franz Baumann designed the original building, which was nearly complete when Ball died in March 1884. Nicholas Clayton designed additions to the building, including the large dome on the north side in 1891. The last class graduated in 1954 before a new facility opened at Fortieth Street and Avenue O.

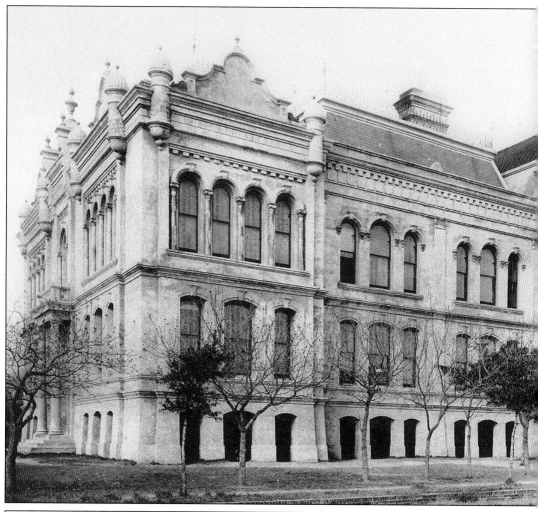

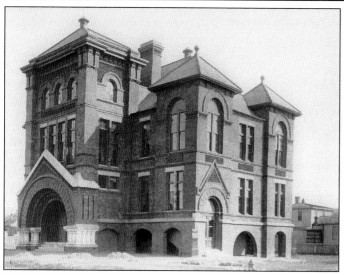

The Bath Avenue (or Fifth District) School stood at the southeast corner of Twenty-fifth Street and Avenue P. Nicholas Clayton completed it in 1893 and designed an addition to it four years later. Although severely damaged, the building survived the 1900 storm. Later known as Sam Houston School, it was sold in 1965 and demolished to make way for a supermarket.

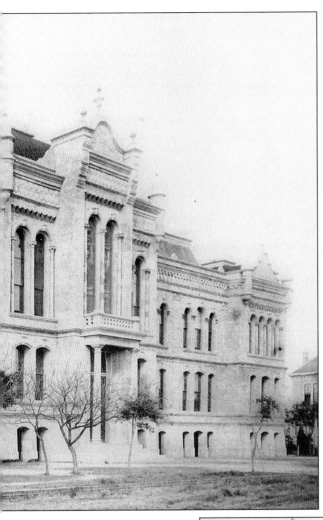

The Henry Rosenberg Free School, completed in 1889, faced Eleventh Street between Winnie and Ball Streets. A gift of Swiss immigrant banker Henry Rosenberg, the building was designed by Nathaniel Tobey and faced Sidney Sherman Park, in the block to the east. Rosenberg oversaw the construction and realized its benefits to the community before he died four years after it opened. He donated a total of $75,000 toward its construction. In his will, Rosenberg made the following statement, "I desire to express in practical form my affection for the city of my adoption and for the people among whom I have lived for so many years, trusting that it will aid their intellectual and moral development and be a source of pleasure and profit to them and their children and their children's children through many generations." This school was demolished in 1965 once a newer building was constructed at Tenth Street and Ball Avenue.

Completed by Nicholas Clayton in 1886, the Avenue K (or Second District) School was located at the southeast corner of Twentieth Street and Avenue K. This was one of the least damaged schools in the 1900 storm, with repairs estimated at the time of $1,500. The building served students in the years immediately afterwards. It was demolished in 1965 after a new San Jacinto Elementary School was built at Twenty-first Street and Avenue K.

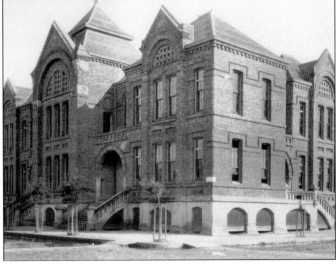

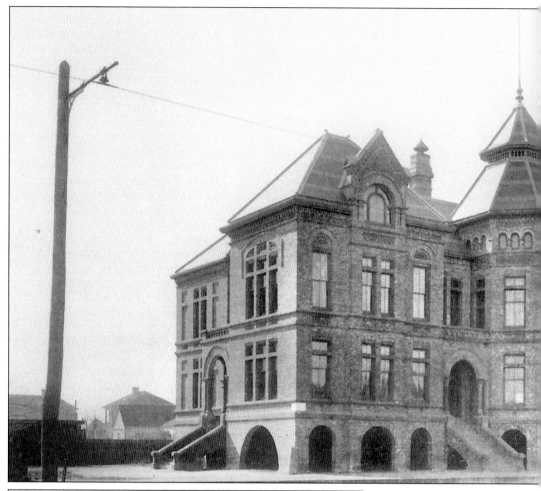

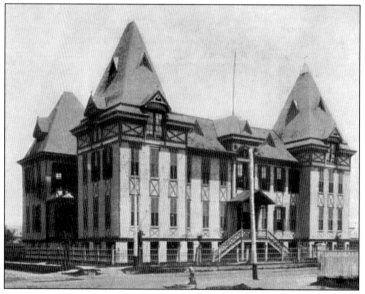

Nicholas Clayton's only wooden school building for Galveston was the Avenue L (Third District or Goliad) School, built at the northeast corner of Thirty-first Street and Avenue L in 1884. This was also his first school commission in Galveston. Estimates after the 1900 storm called for repairs being completed in just over a month at a cost of $3,500. The structure was replaced with a new building in 1924.

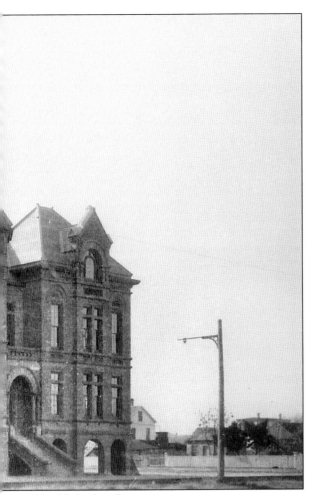

Construction of the West Broadway School in 1891 was delayed for 18 months because of budget concerns. Once completed at the southeast corner of Thirty-eighth Street and Broadway Avenue, the Nicholas Clayton–designed school served western portions of the city until the Alamo School was constructed in 1935. The western section of this building collapsed in the 1943 hurricane, and the remainder was quickly demolished. By that time, the building was owned by Galveston County and held the driver's license bureau. Its bricks were used by the county as road fill. Approximately 100 oak trees along Broadway Avenue were uprooted by the storm's rains and strong winds. Damage from the 1943 hurricane was estimated at more than $1 million, and a major problem was the lack of carpenters and building tradesmen to make repairs, since many were off fighting in World War II.

Established at the southeast corner of Sixteenth Street and Avenue L in 1885, Central High School was the first high school for African Americans in the state. Nicholas Clayton completed this structure, its first permanent facility, in 1893 at the southwest corner of Twenty-sixth Street and Avenue M. An early two-bay addition (at the right) remained after the original structure was demolished when a new facility was opened in January 1954.

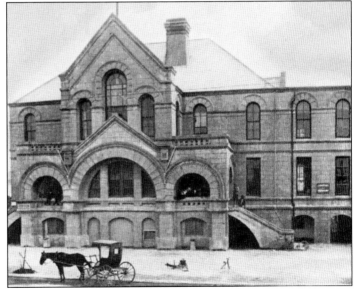

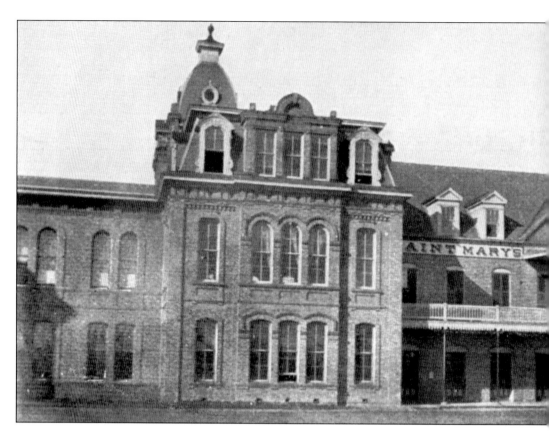

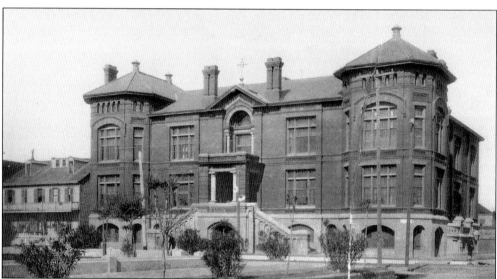

St. Mary's Cathedral School was operated by the Dominican Sisters and was designed by N. J. Clayton and Company. Bishop Nicholas Gallagher laid the cornerstone for the school on May 1, 1892, at the northwest corner of Twentieth and Winnie Streets. The building was completed the following year. Four-hundred-and-fifty students were enrolled at the time it was destroyed in a predawn tornado associated with Hurricane Carla on September 11, 1961.

St. Mary's University was founded as the first Catholic seminary and college in Texas and was granted a charter by the Texas legislature in 1856. The school was officially opened by Bishop Jean Marie Odin in the previous year. The building and grounds suffered damage from Union shells during the Battle of Galveston on January 1, 1863. Four years later, the seminary closed temporarily during a yellow fever epidemic. Nicholas Clayton was commissioned to add wings and a tower to the facility, located at the northeast corner of Fourteenth Street and Broadway Avenue, in the 1880s and 1890s. The university survived until 1922, when the Jesuit order that ran the academy left Galveston. The original 1854 building and east wing were demolished in 1924, with the remainder of the building coming down in 1965 to make way for the Sacred Heart School.

Dedicated by Bishop Nicholas Gallagher on January 17, 1892, Sacred Heart Church was the largest sanctuary in Texas at the time. The structure sat at the northwest corner of Thirteenth Street and Broadway Avenue facing south. It took the full brunt of the 1900 storm and collapsed. Nicholas Clayton proposed a replacement structure, but the design of Brother Philip Jiminez, S. J. was selected. Clayton's only contribution to the work was the replacement dome built in 1910, which was his last project.

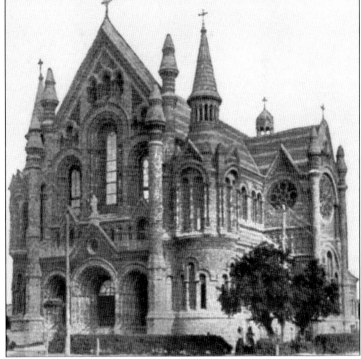

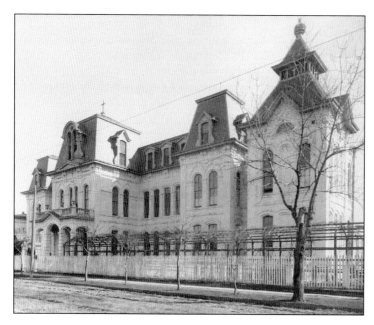

Nicholas Clayton designed St. Mary's Infirmary for the Sisters of Charity of the Incarnate Word at 701 Market Street. Completed in 1876, Clayton designed several additions to the building, including a dormitory and chapel wing along Seventh Street, which were destroyed in the 1900 storm. Clayton replaced them with a novitiate. The hospital survived until 1965, when it was demolished for a newer facility.

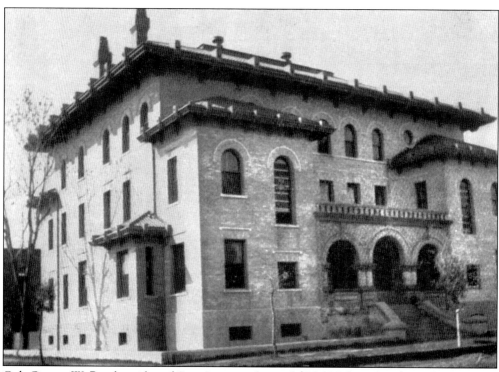

Col. George W. Brackenridge of San Antonio donated $30,000 for a female medical student dormitory in 1896. A larger building was desired, but without support from the state legislature, the design followed the budget of the gift. Architect C. W. Bulger completed the structure in 1898 at the southwest corner of Eighth and Strand Streets. Heavily damaged in the 1900 storm, it survived until September 1945, when an advertisement for salvaged building materials was posted.

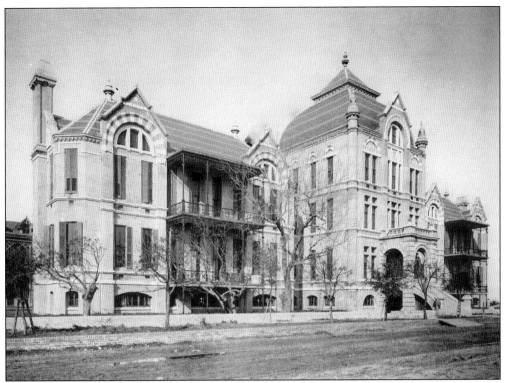

After John Sealy passed away on August 29, 1884, his will directed that $50,000 be designated to "a charitable purpose." This gift made possible the establishment of the University of Texas' medical branch in Galveston, and the research hospital quickly grew. John Sealy Hospital, on the north side of Strand Street between Eighth and Ninth Streets, was damaged in the hurricane of July 27, 1943. A replacement facility was completed in 1953.

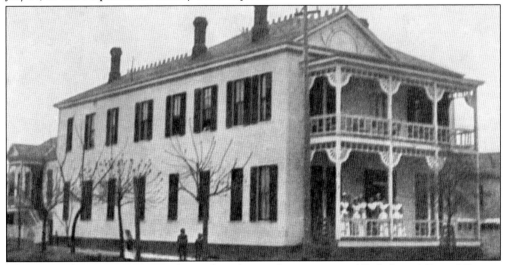

The Trained Nurses Home was located at the southeast corner of Eighth and Strand Streets before the 1900 storm destroyed it. Similar facilities supported John Sealy Hospital, once owned and managed by the City of Galveston but transferred to the University of Texas Medical School in the early 20th century.

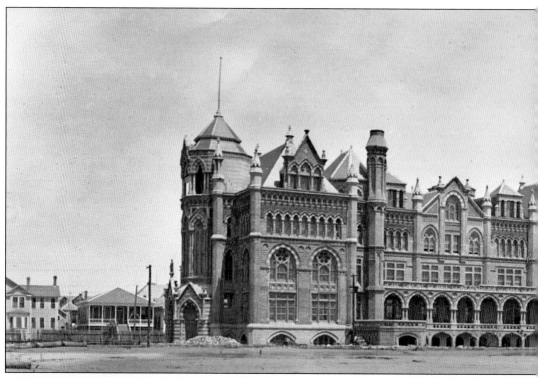

The Ursuline Convent was constructed at Twenty-sixth Street and Avenue N in 1855 after a fire the previous year destroyed the convent's frame home. This building provided refuge during several yellow fever outbreaks in the 19th century and served as a hospital to soldiers from both sides of the Civil War. The structure was demolished in April 1973 after the O'Connell School trustees voted to replace it with an athletic field, which was never built. (Courtesy HABS.)

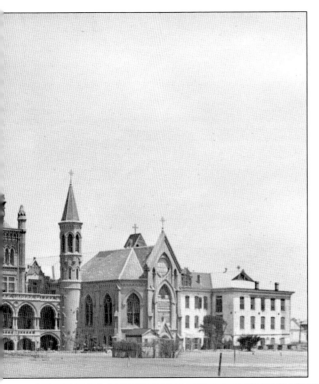

The Ursuline nuns first arrived in Galveston from New Orleans on January 19, 1847, at the request of Bishop John M. Odin. They founded Ursuline Academy, the first Catholic school for girls in Texas, at the corner of Twenty-fifth Street and Avenue N. This photograph shows the south, or back, side of the 1895 Ursuline Academy as it appeared during the grade raising after the 1900 storm. The academy ran parallel to Avenue N between Twenty-sixth and Twenty-seventh Streets. Moving east was the Chapel of Our Lady of the Presentation, which Nicholas Clayton designed the interior and additions to. At far right stood the Ursuline Convent. Clayton completed the academy after nearly four years of construction. The composition of stone and brick masonry, carved wood, stained glass, and encaustic tiles was a masterpiece of design and craftsmanship. (Courtesy Galveston County Historical Museum.)

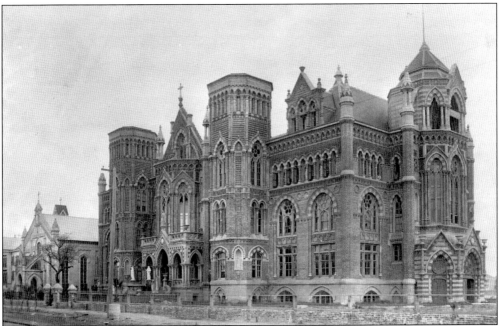

Nicholas Clayton's Venetian Gothic–style Ursuline Academy sheltered to approximately 1,000 people during the 1900 storm. Originally the basement held the dining hall while a reception room filled the first floor. Classrooms and an auditorium were reserved for the second floor. The third floor offered a dormitory and art rooms. This view from the northwest shows the academy and presentation chapel. (Courtesy Galveston County Historical Museum.)

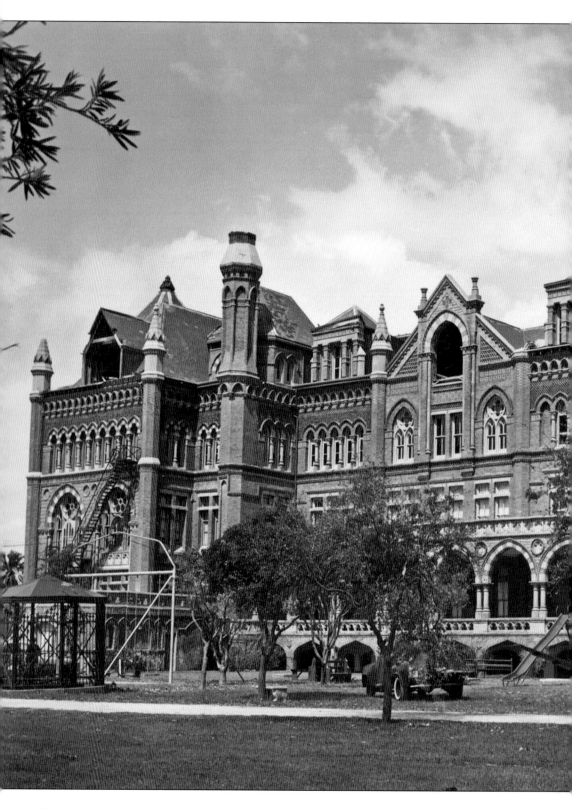

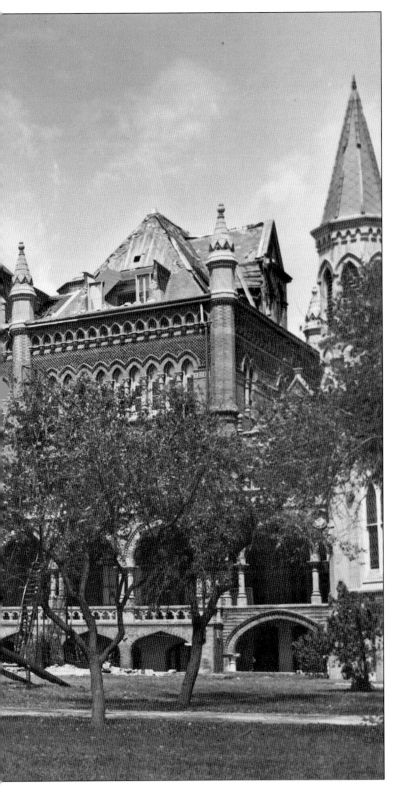

Less than three months after Hurricane Carla made landfall to the southwest of Galveston Island, demolition of the Ursuline Academy began. This photo shows the extent of damage to Clayton's masterpiece after the storm of September 11, 1961. A representative of the school expected the facility to be reopened for classes just one week after the storm. By comparing this with the photo at the top of the previous page, we see how minor damage was, compared to the size of the school. Several dormers were heavily damaged, a few windows blown in, shingles and finials removed, but hardly severe enough to condemn it to the wrecking ball. The site remained vacant, with only the carriage stone along the 2600 block at Avenue N (Ursuline Avenue) as a reminder of the craftsmanship that once was. (Courtesy Galveston County Historical Museum.)

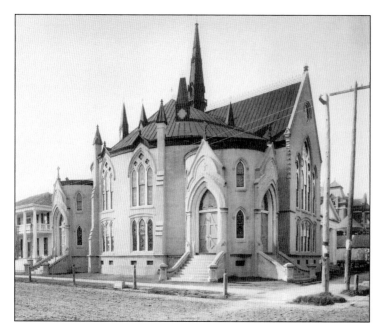

Architect Nathaniel Tobey Jr. designed this version of the First Baptist Church, which stood at the northwest corner of Twenty-second and Sealy Streets. Completed in 1883, the building was a playful composition of European and Eastern Orthodox forms. This structure was destroyed in the 1900 storm, after which the church met in temporary facilities at the YMCA building at Twenty-third and Winnie Streets for several years.

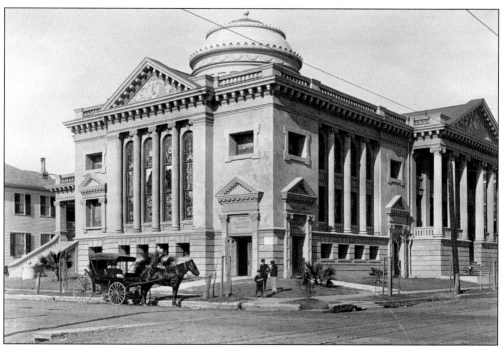

Sermons were first given in the replacement First Baptist Church on May 17, 1903. This domed structure, designed by Charles Bulger, boasted a kitchen and a nursery, novel features in churches at the time. Materials salvaged from the church destroyed in the 1900 storm were used in its construction. This sanctuary was demolished in October 1962 after a new Colonial-style church was completed on the site of the John Sealy residence. (Courtesy Galveston County Historical Museum.)

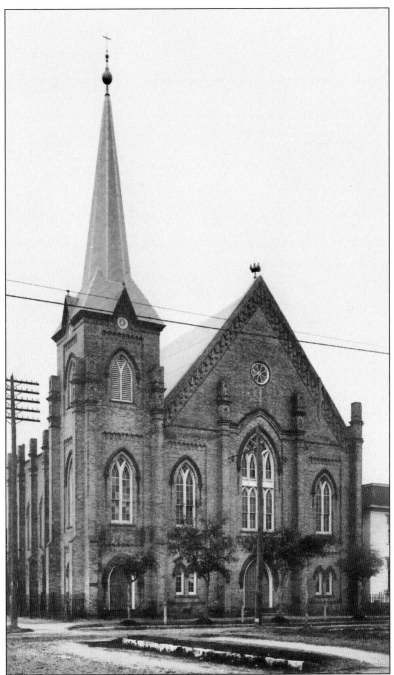

The cornerstone for St. John's Methodist Church was set at the southwest corner of Broadway Avenue and Twenty-fifth Street on April 2, 1869, by Peter W. Gray of Houston, grand master of the Masons in Texas. The church provided a larger place of worship for Methodists as they outgrew the Ryland Chapel at Twenty-second and Church Streets. Once St. John's Church was finished, the 1843 wood chapel was sold and moved to the western part of town, clearing the way for the construction of Harmony Hall on its site. The roof of St. John's Church collapsed in the 1900 storm, and the building was replaced by a mission-style sanctuary designed by George B. Stowe.

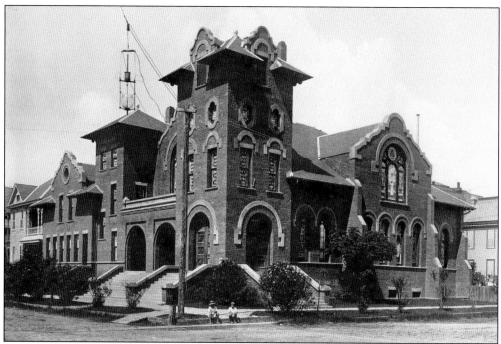

Charles W. Bulger designed this sanctuary for Central Christian Church at the southwest corner of Twentieth Street and Avenue K. Galveston's first brick-veneered building was dedicated in 1895 and showed the influence of H. H. Richardson's popular Romanesque style of architecture. The structure was later used by the Church of Christ from 1930 until being demolished in 1964 to make way for San Jacinto Elementary School. (Courtesy Galveston County Historical Museum.)

In the early 20th century, Ponziano Del Papa ran a corner grocery at 2701 Ball Street in a two-story structure on this site. By the 1950s, St. Vincent's Chapel and Community Center operated from this wood-frame building as an outreach of Rev. Fred Sutton and the St. Augustine of Hippo Episcopal Church. St. Vincent's moved in 1975, and the building served as a private residence before being demolished in the mid-1980s.

Four

COMMERCIAL AND INDUSTRIAL

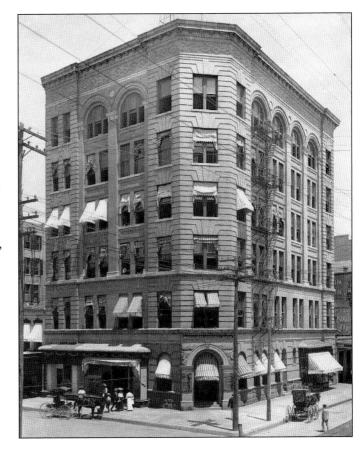

George B. Stowe designed the Improvement Loan and Trust Company Building at the northeast corner of Tremont and Postoffice Streets. Completed in 1900, the building was claimed to be the first skyscraper in the southwest. It was the first location of the City National Bank, later to be known as Moody National Bank. The Trust building was demolished in June 1956 when the owners felt it would cost too much to modernize. (Courtesy Galveston County Historical Museum.)

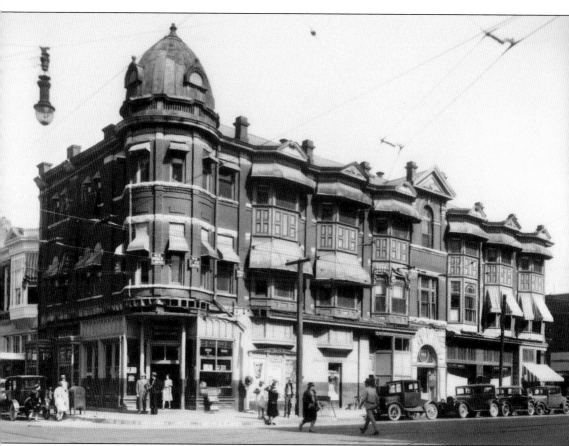

The Gill-League Building was completed in 1892 at the southeast corner of Twenty-First and Market Streets. It housed a variety of businesses at the street level, including dentists, florists, real estate developers, and the Verkin Photograph Company, which produced this picture. Witherspoon's Pharmacy occupied the corner space for years, while the upper floors served as apartments. In 1907, the building was the birthplace of Douglas "Wrong Way" Corrigan, who worked on Lindbergh's *Spirit of St. Louis* and made a solo flight from New York to Ireland in 1938. Corrigan made the transatlantic flight after being denied clearance from authorities and swore that faulty gauges on the airplane were to blame. The American National Insurance Company (ANICO) purchased the building shortly after its office tower was completed nearby. At this time the Interurban Queen Cigar and Newsstand moved to a building down the block. With parking needed for employees at its headquarters ANICO demolished the Gill-League Building in July 1973. An advertisement in the *Galveston Daily News* from that time offered bricks from the building for sale for 10¢ each. (Courtesy Dolph Briscoe Center for American History.)

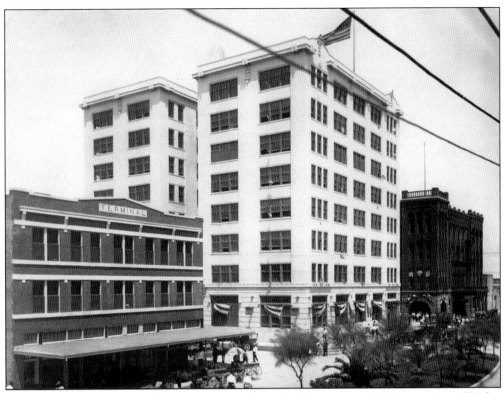

The Terminal Building (left) was constructed on the former site of Galveston Iron Works. Restaurants and other businesses catering to rail passengers filled the ground level of the building, located at the intersection of Twenty-fifth Street and Santa Fe Place. In the 1940s and 1950s, the upper floors served as the Hotel Powell. The building was home to the Salvation Army in the 1980s before being demolished. (Courtesy Galveston County Historical Museum.)

American National Insurance Company built this tower at the northeast corner of Twenty-First and Market Streets in 1913. Founded by W. L. Moody Jr. in 1905, the company grew into a nationwide provider of many types of insurance. This early headquarters was demolished in August 1972 after a new office tower was completed one block to the east. (Courtesy Galveston County Historical Museum.)

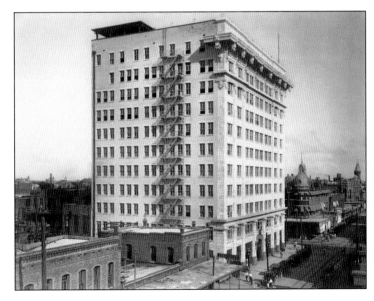

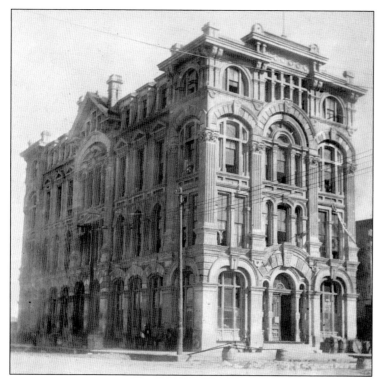

The Gulf, Colorado, and Santa Fe Railroad was founded in Galveston in May 1873. Nicholas Clayton completed a three-story headquarters for the railroad in 1882 and added a fourth floor 10 years later. Located at the northeast corner of Twenty-fifth and Strand Streets, the building was destroyed by fire in April 1907. At the time of its construction, the harbor basin extended south to the alley at the back of this building. (Courtesy Galveston County Historical Museum.)

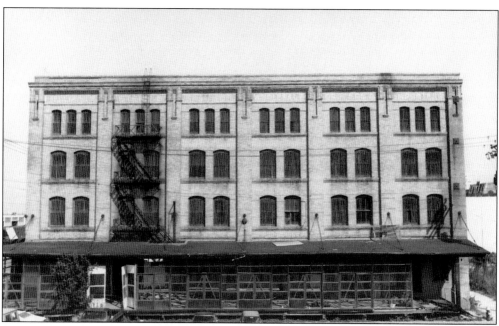

Henry C. Cooke designed this warehouse at 108 Twenty-fifth Street in 1909 for the wholesale grocery firm of Ullmann, Stern, and Krause. The building was sold in 1938 to C. P. Evans, owner of the Galveston Piggly Wiggly stores, and was used until 1965. A proposed 1976 project to turn the warehouse into 38 solar-heated and cooled apartments did not materialize. Instead, the structure was demolished in 1979 for a parking garage.

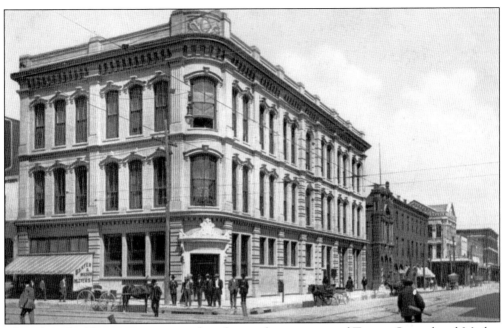

The Alvey Building was constructed at the northwest corner of Twenty-Second and Market Streets and housed shops and restaurants. In 1899, the first services for the Galveston Christian Scientists Church were held on an upper floor. The building was used by the Texas Bank and Trust Company (later the U.S. National Bank) until an 11-story building was constructed to the south, across Market Street. This structure was demolished in 1934. (Courtesy Galveston County Historical Museum.)

The firm of Focke, Wilkens, and Lange operated a wholesale grocery, commission merchant, and importing firm from this warehouse at the southwest corner of Twenty-fourth Street and Avenue A. This warehouse was built around 1880 for the wholesale firm of R. J. Willis and Brothers and was later the Schumacher Company wholesale grocery. The structure was demolished around 1980.

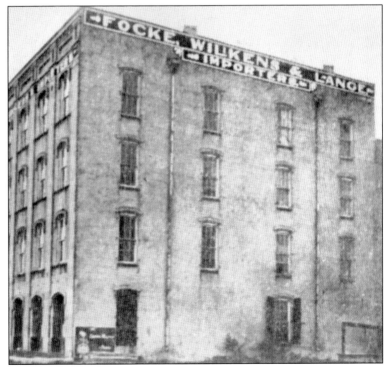

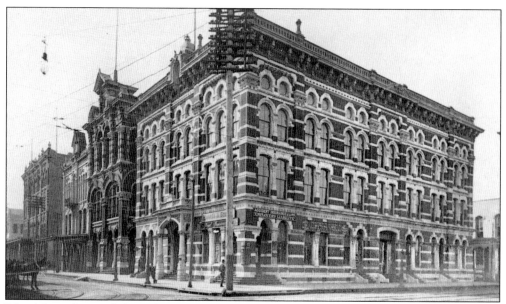

John Moser designed the Galveston Cotton Exchange at the northwest corner of Twenty-First and Mechanic Streets in 1878. The organization was founded in 1873 by Galveston cotton factors (traders) who worked to get premium prices in the market for Texas cotton. This building was demolished in 1940 and replaced by a three-story, air-conditioned structure designed by Galveston architect Ben Milam.

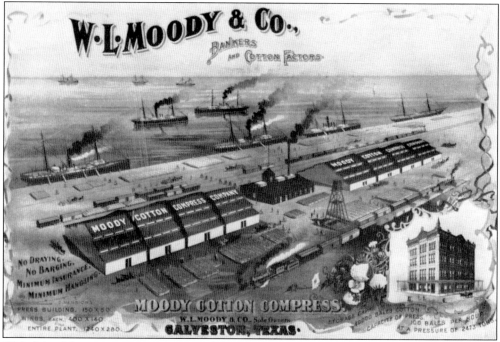

W. L. Moody's cotton compress occupied the area between Pier 29 and Pier 33. Colonel Moody served as president of the Galveston Cotton Exchange and in the Texas legislature. His business ventures were varied and included banking, railroads, and insurance. The Moody family has played a leading role in the financial interests of the city since the second half of the 19th century.

Nathaniel Tobey's earliest known building in the city was the Galveston City Company office, completed in 1872 at the southeast corner of Twenty-second and Ball Streets. Around 1900, it served as the First Church of Christian Science. By the 1940s, the building housed the American Legion Hall before being demolished for a bus station in the following decade.

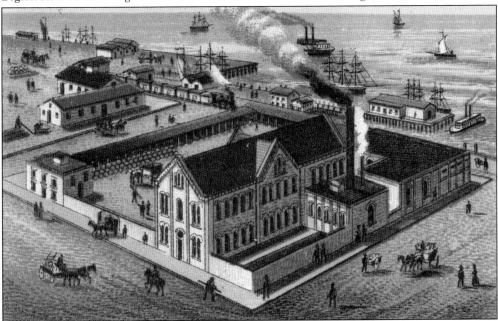

The Galveston Oil Company's Cotton Seed Oil Mill filled the block between Seventeenth and Eighteenth Streets on the north side of Strand Street. Built in 1881, it was later purchased by the National Cotton Oil Company. The mill was dismantled in 1930 to make way for Galveston's third monumental U.S. Custom House, which was completed three years later.

The 1888 Galveston Baggage and Cordage Factory occupied the block at the northwest corner of Thirty-eighth and Winnie Streets. Designed by Massachusetts architect D. H. Dyer, its workroom boasted 100 English-made machines for cording, spinning, and weaving jute into bags for cotton bales. The factory was closed in 1896, and the space was used as a cotton warehouse until being demolished in 1969 to construct an apartment block. (Courtesy HABS.)

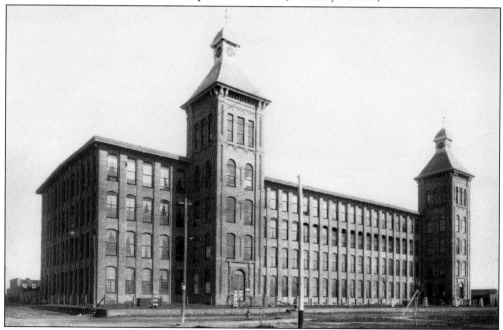

The Galveston Cotton and Woolen Mills occupied the block on the north side of Winnie Street between Fortieth and Forty-first Streets. Completed in 1890 by the Providence, Rhode Island, engineering firm of C. R. Makepeace and Company, it was later known as the Cotton Pickery. While being demolished in 1969, sparks from a nearby construction site blaze ignited the old-growth pine timbers and completed the job of destruction.

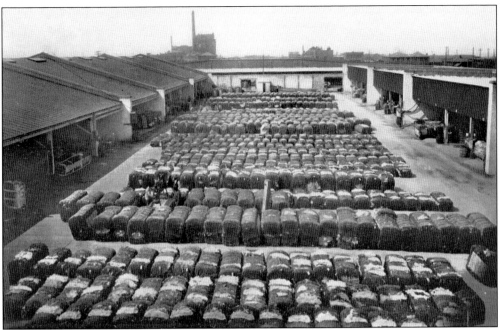

Cotton compresses, warehouses, and mills dotted the city in the late 19th and early 20th century. Railroads brought tons of cotton from across the region and prepared them for ports in Europe and New England. The Merchant and Planters yard, seen here in the late 1890s, had a storage capacity of 26,000 bales. Jobs and returns on investments from the railroads, mills, and shipping fueled the city's prosperity during this time.

A charter was granted to the Gulf City Cotton Press and Manufacturing Company in 1874. By 1885, the facility filled three city blocks between Twenty-ninth and Thirty-first Streets, and Winnie and Sealy Streets. Later known as the Merchant and Planters Cotton Press, the site was vacant by the late 1940s. In 1954, the last campus of Central High School, designed by Fort Worth architect Preston M. Geren, opened at this location.

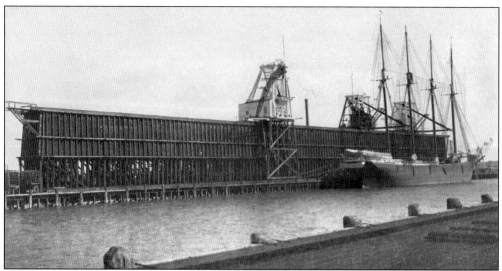

The 450-foot-long coal elevator for the steamship agents and brokerage firm of Fowler and McVitie was constructed in the 1890s at Pier 34. The company coordinated the shipping of goods between Europe, Panama, the Caribbean, and Galveston. Galveston sat at the crossroads of shipping and rail trade routes, and the availability of coal made it the main source of heat in most homes of the late 19th century.

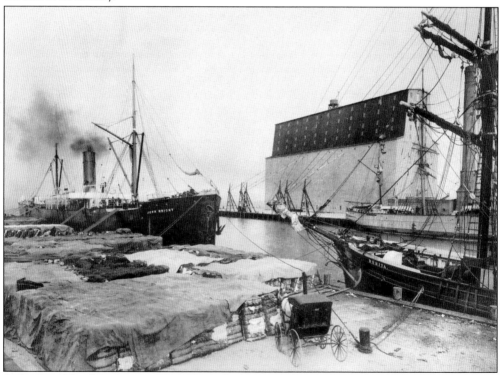

Galveston Wharf Company's Elevator A stood 15 stories tall along Pier 14 and had a capacity of 1 million bushels. It served the Galveston Wharf Company from 1893 to 1933, when it was demolished to make room for a transit shed. At the time the elevator was constructed, James Moreau Brown (of Ashton Villa) was president and Henry Rosenberg was vice president of the company.

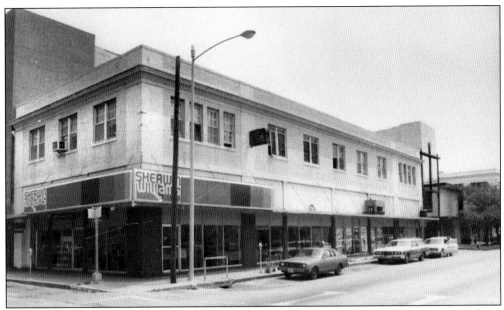

H. L. Nelson constructed this commercial building at the southeast corner of Twenty-second and Church Streets for his furniture business on the ground floor and apartments upstairs. By the end of World War II, it was occupied by Sherwin Williams Paint Company and the Maye Hotel. The building burned on January 19, 1983, just two weeks after the fire marshal closed the hotel for fire code violations.

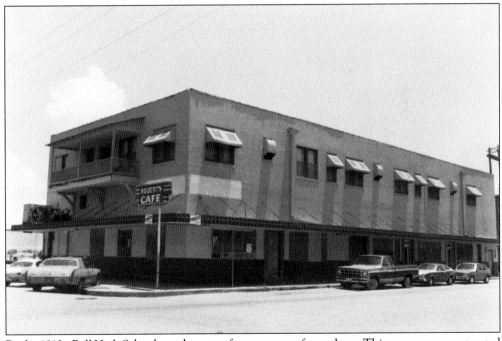

By the 1910s, Ball High School was desperate for more room for students. This annex was constructed at the southeast corner of Twenty-first and Ball Streets, overlooking City Park. After several wings were added to the school, it became the Ball High Confectionery, with Star Apartments above. The building was demolished shortly after this photograph was taken of Robert's Café in 1977.

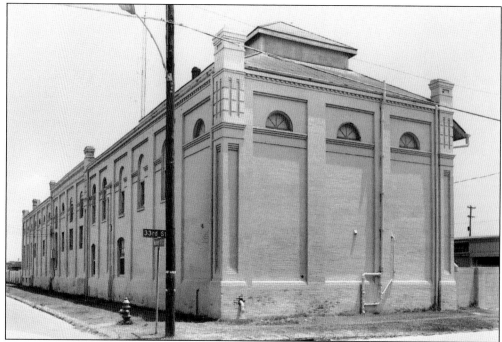

S. R. Dickson engineered this distribution plant for the Galveston Gas Company in 1860 at the southeast corner of Thirty-third and Market Streets. It was one of the first plants of its kind in Texas. By the mid-20th century, it served as a stand-by plant for the Texas Public Service Company. The Southern Union Gas Company demolished the structure in 1998.

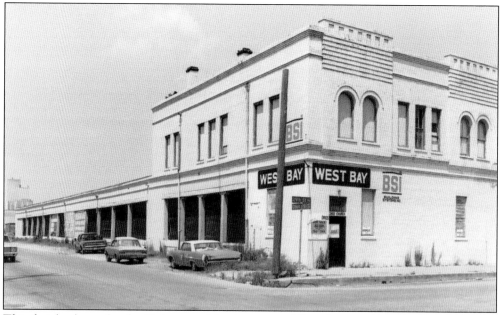

This freight depot for the Galveston, Henderson, and San Antonio Railway Company was completed in 1918 at the northwest corner of Twenty-ninth and Church Streets. During the 1940s and 1950s, it served as the Texas and New Orleans Railroad Company Freight Depot. The Galveston Park Board demolished the structure in 2009 to build a new warehouse.

The Galveston, Henderson, and Houston Railroad built this depot at 413 Thirty-third Street in the early 20th century. Located near the Galveston Brewing Company (later Falstaff Brewing Corporation), it served as a materials, signage, and general storage warehouse for the railroad in the mid-20th century. The structure was demolished after the late 1970s.

The Missouri Pacific Railroad constructed this depot in the late 1880s at the southwest corner of Thirty-third and Mechanic Streets. Six years later, the building served as the inbound freight house for the Galveston, Houston, and Henderson Railroad Flat Cotton yard. It functioned as the Schlitz Beer Warehouse in the late 1940s and as the building material warehouse for the Gulf Lumber Company from 1950 until the late 1970s.

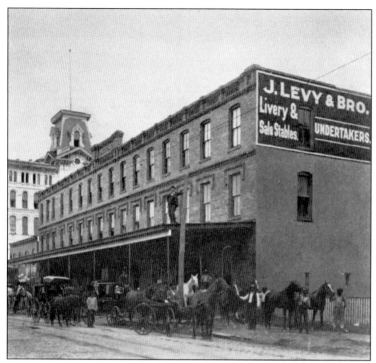

This building was constructed around 1892 at 2216–2220 Church Street for J. Levy and Brothers undertakers and funeral directors. The company also ran a livery business from this location. The building was surveyed for the Galveston Historical Foundation by Ellen Beasley in 1982, when it was the Universal Parking Garage. On September 1 of that year, water from a morning thunderstorm collected on the roof and caused its collapse.

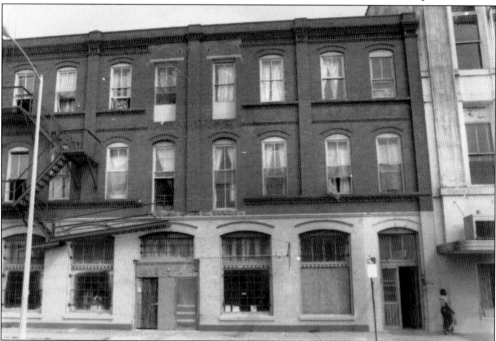

J. Levy and Brothers constructed this building at 2208–2212 Church Street in the early 1900s. By the 1930s, Star Auto Trimmers repaired automobile interiors here, and in the 1940s, the Baines Motor Company sold De Sotos on first floor. The upper floors were a boardinghouse. A fire on March 4, 1989, started in the vacant building when a transient tried to keep warm during bitterly cold weather.

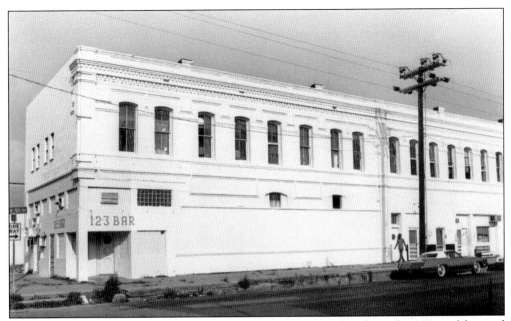

The commercial building at 2602 Market Street was constructed in the early 1890s and featured the clothing store of Jacob Littmann and Son. Subsequent saloons, cafes, clothing, and dry-goods stores occupied the ground level while the upper floor served as a hotel. It was the One, Two, Three Bar and Janie's Ballroom before being demolished by the mid-1980s.

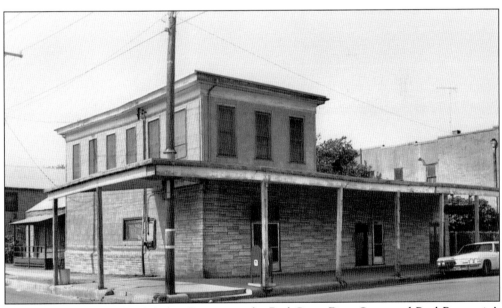

This corner store at 2701 Market Street was the Red Cross Drug Store and Paul Bronstein's clothing store during the first decades of the 20th century. Subsequent uses include a barbershop, restaurants, a music store, a dry cleaner, a newsstand, and the North Pole Confectionery. By 1977, it was the home of the Show Place Bar and Show Place Shine Parlor. The building was listed for sale in 2002 and was demolished shortly thereafter.

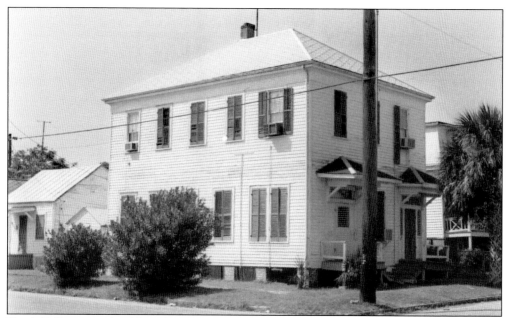

Frank Bell, a specialized longshoreman called a screwman, lived at 2801 Avenue L during the 1910s. Thomas H. Warren, a teacher at Central High School and later principal at George Washington Carver School, lived here in the 1930s and 1940s. The Carver School was located at 3502–3528 Avenue N until being demolished in the late 1970s. Lizzie and Julius Phelps, another longshoreman, lived here in the late 1950s. This house was demolished around 2000.

This building, at 2702 Postoffice Street, appears on the 1885 Sanborn Fire Insurance Map and was a saloon in the early 20th century. During Prohibition, William Alexander sold soft drinks from this building. It was the Big Tree Café in the late 1940s, serving the African American community during segregation. George Washington's Rooming House and Demolishing Office operated here in the 1970s, and by 1985, it was Mama's Bar-B-Que.

On July 21, 1907, Robert Crossman applied for a license to sell liquor at 2627 Mechanic Street. The deep canopy that extended to the curb was typical for many commercial establishments in Galveston. A news article from February 1947 reported that the apartment of the boardinghouse operator Emile Durgons was burglarized. The building was advertised for sale in 1977, when this photograph was taken.

In August 1921, Ed Licata and Sons opened a meat market at 2702 Ball Avenue. By 1955, Hyman Bronstein operated the H&B Food Store. It was sold to Ida and Joe Bronstein in February 1968 and continued operation under the same name. The wooden structure was covered in asbestos siding that was popular in the mid-20th century.

In 1934, Bozo the Wonder Dog appeared at several locations, including Montoya's Bar, sponsored by distributors of Grand Prize Beer. In the early 1950s, the Galveston Police Department conducted several raids on the Rio Grande Club at 2715 Market Street in an effort to clean up illegal gambling and liquor sales. A raid on several bawdy houses brought the police back to the rooms above the Rio Grande Club in April 1956.

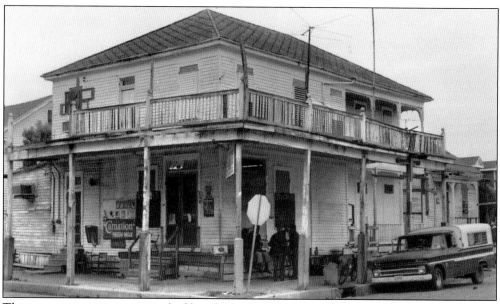

This corner grocery was typical of hundreds that once served the neighborhoods across the island. Early proprietors include Samuel Licata and Nello Galli. John Listowski operated the J&M Grocery in the late 1950s, and by the late 1970s it was Jule's Store. The property at 3228 Avenue M ½ was sold with four rent houses in 1984 and demolished the following year.

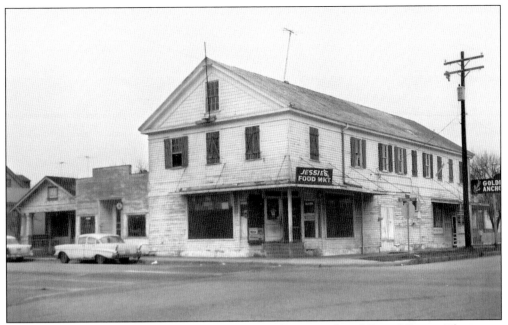

These three structures stood at the southeast corner of Fourteenth and Strand Streets. The corner store was constructed by 1889 and housed Paulo Pasquale's grocery in the 1910s. Jessie's Food Market and the Golden Anchor Tavern occupied the building during the 1960s. The structure was demolished by the University of Texas Medical Branch after 1970 to construct a warehouse.

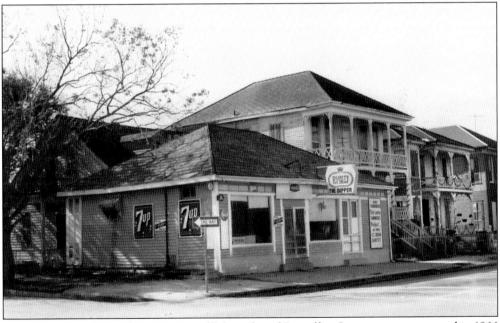

This building at the southwest corner of Fifteenth and Postoffice Streets was constructed in 1866 as a carpenter's shop. Pharmacist Edmund J. Cordray purchased the shop in 1918 and operated a drugstore here until his death in 1965. The building was demolished around 1977, despite being designated a Recorded Texas Historic Landmark 10 years earlier. The East End Historical District Association later moved a cottage to the site from 618 Market Street.

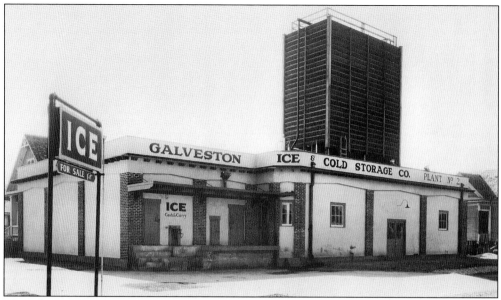

This substation for the Galveston Ice and Cold Storage Company was constructed at the southwest intersection of Thirty-ninth Street and Avenue N ½ in 1928. The company was instrumental in getting food to troops during World War I and making gulf seafood available to the rest of the country from its headquarters at Twentieth Street and Avenue A. This substation was sold in July 1972.

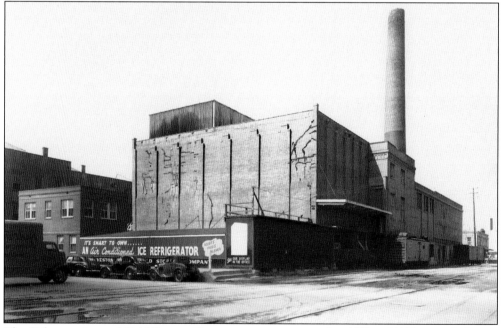

The Galveston Ice and Cold Storage Company was constructed in 1912 at 111 Twentieth Street. During demolition of the larger plant in November 1978, its roof and east wall collapsed, destroying the storefronts and upstairs apartments along Twentieth Street. The Hill family, owners of the building, donated the smokestack to the Galveston Historical Foundation, which rehabilitated it in 2005. It serves as a reminder of the area's industrial past.

James Moreau Brown, owner and builder of Ashton Villa, constructed this commercial building for Edmund L. Ufford at the southwest corner of Twenty-third and Mechanic Streets. Completed in February 1861, the building served the downtown business district for more than 100 years. It was slated to be demolished for a parking lot for an adjoining bank and under a federal court order to halt demolition when fire destroyed the vacant structure on February 2, 1978.

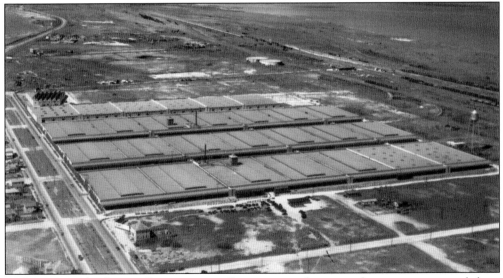

Built in 1928, the Cotton Concentration Company warehouses and compress measured three blocks long by four blocks deep. They were connected to rail lines to receive cotton for export and ran west along Broadway Avenue from Fifty-fourth Street. Additional buildings were added, but by the 1980s all were vacant. The western-most sheds were razed in 1995, and Galveston County demolished the remaining buildings in 2004 to construct the Galveston County Justice Center. (Courtesy Dolph Briscoe Center for American History.)

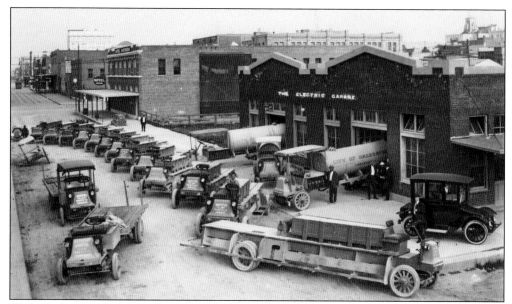

W. D. Haden founded the Galveston Island Transfer Company in 1915 and maintained a fleet for cotton and heavy hauling. Later used as the Electric Storage Garage, the building is still extant at 2525 Mechanic Street, although heavily altered. This is not the case with the Hotel Southern at 301 Twenty-fifth Street, pictured in the background. A fire on September 4, 1967, originated in an automobile repair shop, destroying five businesses and what was then known as the Union Hotel. (Courtesy Dolph Briscoe Center for American History.)

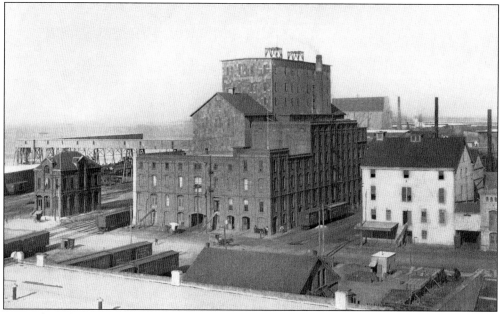

Located on the north side of Avenue A, between Twentieth and Twenty-first Streets, the Texas Star Flour Mills was completed in 1889. Old-growth timbers sheathed in corrugated iron were used in the construction, overseen by Nicholas Clayton. It was last used in 1957 and was acquired by the Galveston Wharves for expansion in 1972. One condition of the purchase was the removal of the mill, which took nearly two years to dismantle.

The Block Meat Company occupied the concrete building at 2306 Strand Street, sandwiched between two surface parking lots. It was constructed in 1916 after the original building was destroyed in the hurricane of the previous year. George and Cynthia Mitchell developed Saengerfest Park at this corner in the early 1990s as a public plaza for visitors to the Strand National Historic Landmark District.

The firm of Toujouse and Sancho, importers, wholesale, and retail dealers in wines, liquors, cigars, and table luxuries, was located at the northwest corner of Twenty-third and Postoffice Streets. Nicholas Clayton completed this structure in 1898. Henry Toujouse also operated the Stag Hotel upstairs. The Toujouse Bar is owned by the Galveston Historical Foundation and is on permanent loan to the Tremont Hotel at 2300 Ships Mechanic Row.

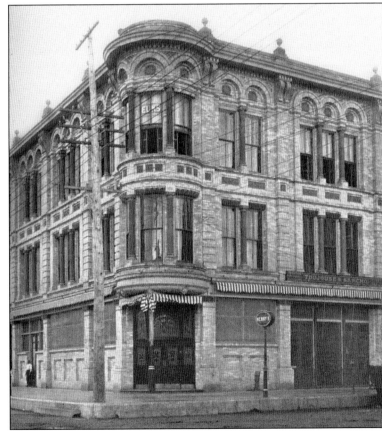

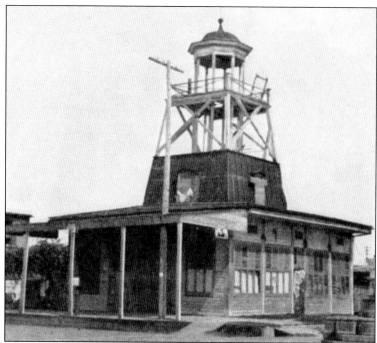

This neighborhood market house was constructed at the northwest corner of Eleventh and Mechanic Streets in 1868 at the bequest of a local citizen. One condition of the gift was the inclusion of a bell tower to alert neighbors of fires and to guide ships in the harbor. The bell also rang each day at 7 a.m. to announce the start of the workday. The structure was demolished in 1904.

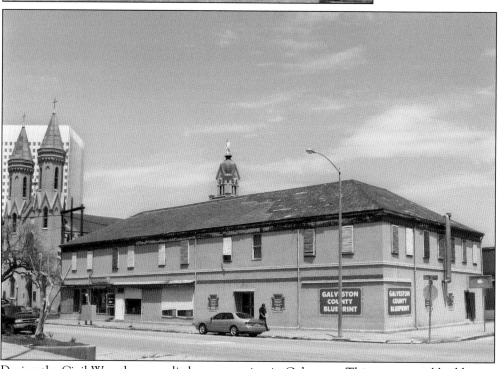

During the Civil War, there was little construction in Galveston. This commercial building at the northeast corner of Twenty-first and Winnie Streets was one of the first constructed after the war. It featured a boardinghouse upstairs with numerous shops below. The Galveston-Houston Catholic Archdiocese demolished the building in August 2009 to make a parking lot, despite several offers to purchase the building to save it.

Five

STREET SCENES

Dr. John F. Y. Paine was an early physician, surgeon, and professor at the University of Texas. His residence stood at 2427 Broadway Avenue until being demolished in the late 1940s for a gas station. Henry Rosenberg's *Texas Heroes Monument* was designed by sculptor Louis Amateis and was dedicated on San Jacinto Day in 1900. City leaders considered removing the monument from Broadway Avenue in 1967 to make turning easier for drivers at the intersection.

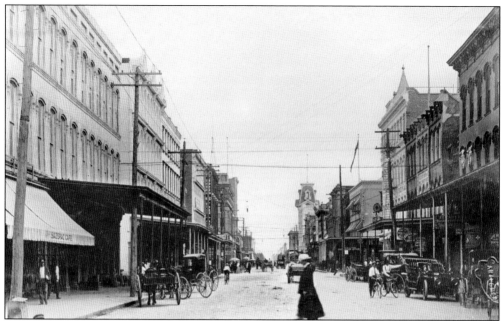

This is a view of Tremont Street looking south from Strand Street around 1920. On the left was the Sazerac Café and Muller Printing Company. Farther south, across the alley, was an 1860s building that served many tenants, including Clarke and Courts Printing, Galveston Typewriter Company, and Galveston Labor Temple. The Kon Tiki Club occupied the building until it was destroyed by fire during Hurricane Alicia in 1983. (Courtesy Galveston County Historical Museum.)

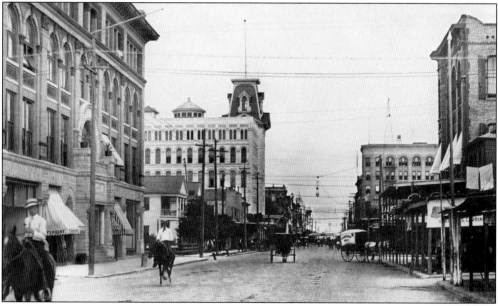

Since the founding of the city in 1839, Tremont Street has been one of the busiest commercial streets. Looking north toward the harbor from Ball Avenue was Henry Rosenberg's YMCA Building and the Tremont Hotel on the west. Electric lines for buildings, streetlights, and streetcars webbed across the sky. The three-story building to the east was the Tartt Apartments. (Courtesy Galveston County Historical Museum.)

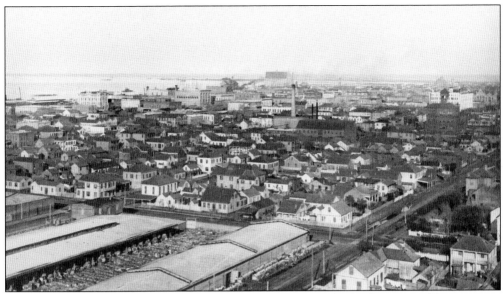

The area west of Twenty-fifth Street was filled with houses, boardinghouses, and businesses at the beginning of the 20th century. This 1894 view looking northeast from the top of the water standpipe at Thirty-first and Ball Streets shows the Factors' Cotton Press and the intersection of Twenty-ninth and Winnie Streets. Large buildings such as the U.S. Custom House and Tremont Hotel can be seen in the background.

Looking southeast from the same standpipe, the Beach Hotel stands at the upper right, near Clayton's Ursuline Academy at Twenty-seventh Street and Avenue N. Most streets outside of downtown were not paved until after the 1900 storm and subsequent grade raising. The wide Broadway Avenue can be seen in the middle, with only a few oleanders along the esplanade. Trolley lines once occupied the lanes adjacent to the median.

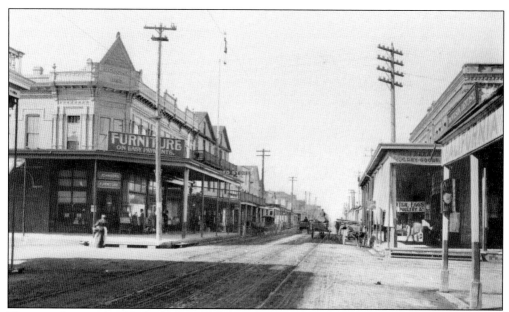

This was the view in 1894 looking west down Market Street from Twenty-sixth Street. Dr. Jesse Wilson occupied an upper office at the northeast corner (right). Johnson's Furniture occupied the ground floor of the Joghin Building, which had just been completed the previous year at the southwest corner of the intersection. Trolley lines can be seen in the dirt streets.

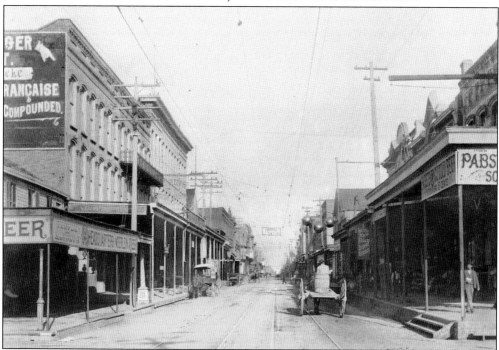

Looking east down Market Street from Twenty-fifth Street in 1894, nearly every building had canopies to shelter shoppers and signage to direct patrons. Signs for saloons, furniture shops, and an apothecary can be seen. Most buildings in the foreground to the south (right) still remain to this day, while all on the north side of this block were demolished during the 20th century.

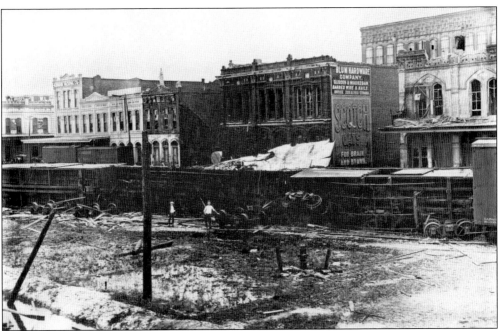

This is the view of the 2300 Block of Avenue A (now Harborside Drive) after the 1900 storm, showing railcars overturned by the storm surge. Only the 1876 J. Mayrant Smith Building (two-story light-colored building) remains along that block today. The Armour Packing Company and Blum Hardware warehouse buildings were demolished. The back of Nicholas Clayton's Greenleve, Block, and Company Building can be seen at the upper right. (Courtesy Galveston County Historical Museum.)

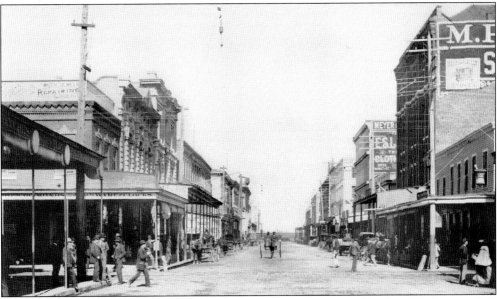

Wood blocks paved many streets in the downtown by 1894, when this photograph was taken looking north on Tremont Street from Market Street. The Tiernans' Two Brothers' Saloon (right) stood at 2228 Market Street, while at the intersection with Mechanic Street was the firm of Meyer and Beneke. The business offered wholesale and retail china, glass, mantles, grates, and toys. Nothing seen here on the east side of the block remains.

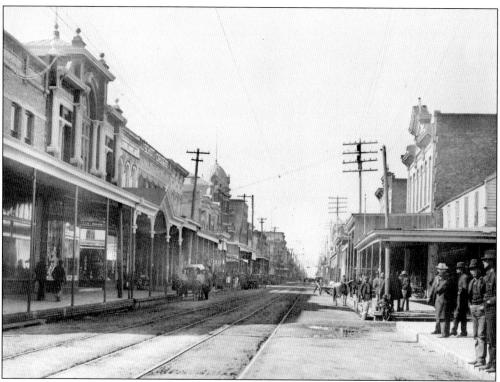

This photograph was taken standing in front of city hall (see page 19) looking west down Market Street from Twentieth Street. The prominent grocery firm of Peter Gengler is seen at left, with large columns on the upper floor. Farther west was the shop of the druggist and chemist Justus Schott and the dome of the Gill-League Building. No building recognizable in this photograph remains.

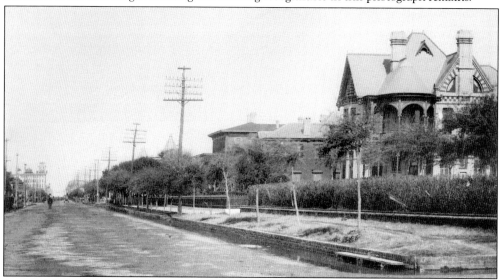

Some of the most prominent business leaders of the late 19th century resided on Tremont Street, including John W. Harris, Col. W. L. Moody, and Alphonse Kenison (see pages 56 and 57). High curbs helped protect pedestrians in times of heavy rains or overflows from the gulf waters. The tower of the Tremont Hotel can be seen in the distance at the northwest corner of Tremont and Church Streets.

This photograph looks north on Twenty-second Street from the alley between Postoffice and Market Streets in 1894. At the right was the Southeast Texas Lands Building and Thomas Goggan and Brothers firm for musical instruments at 2128 Market Street. Buildings in both blocks on the left, including the Alvey Building (see page 95), with its rounded corner parapet, were replaced by banks in the 20th century.

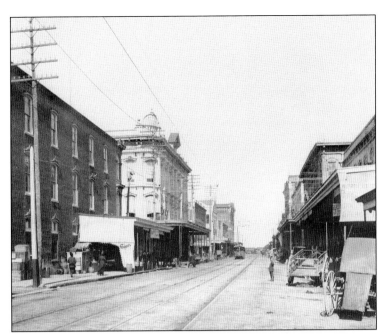

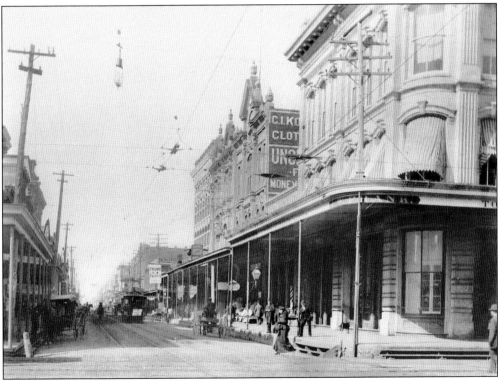

When this photograph of the northwest corner of Twenty-second and Market Streets was taken in 1894, Jacob W. Frank was proprietor of the Louvre, a shop selling toys, dry goods, and household items. Bon Ton Restaurant was to the west. Charles Kory operated a clothing store in the adjacent building. By the early 1970s, this entire block between Mechanic, Market, Twenty-second, and Twenty-third Streets was razed to construct a concrete and glass bank in the brutalist style.

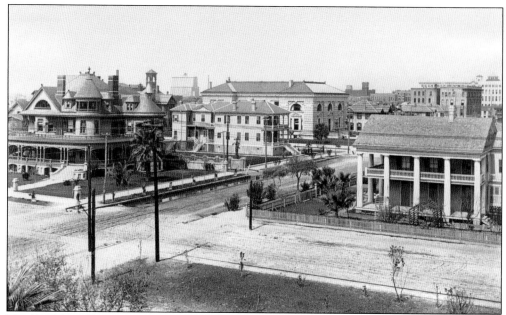

The Frosh/Conklin residence (right) was constructed at the northeast corner of Tremont Street and Broadway Avenue at the time when Texas was still a republic. Although surviving many storms, it was demolished in 1940 to make way for a Sears, Roebuck, and Company department store. The only recognizable building in this photograph that survives today is the 1904 Rosenberg Library at Tremont and Sealy Streets. (Courtesy Galveston County Historical Museum.)

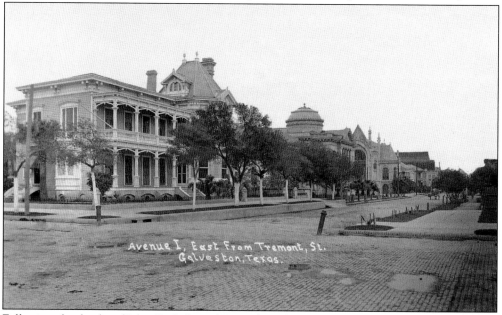

Following the deaths of John Sealy Jr. and Waverly and Jennie Smith (John's sister and brother-in-law), Maco Stewart purchased their residence at the northeast corner of Tremont and Sealy Streets. Stewart donated the property to the First Baptist Church as a memorial to his father and grandfather. Both the Sealy residence and the First Baptist Church of 1903 were replaced by a new church in the 1950s. (Courtesy Galveston County Historical Museum.)

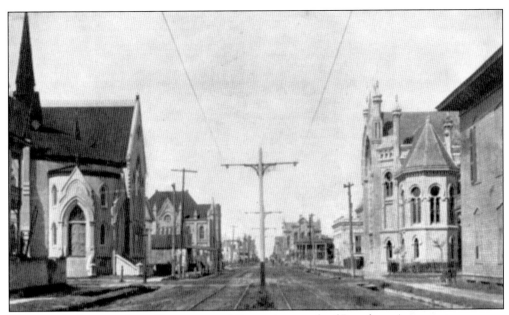

This view looking north on Twenty-second Street, just north of Broadway Avenue, gives a sense of the monumental architecture that greeted immigrants in the late 19th century. Riding north on the electric streetcar, rails passed the Artillery Hall (right) and Hebrew B'nai Israel Synagogue (extant). On the left was the First Baptist Church and Eaton Chapel (extant). Harmony Hall can be seen in the distance on the right.

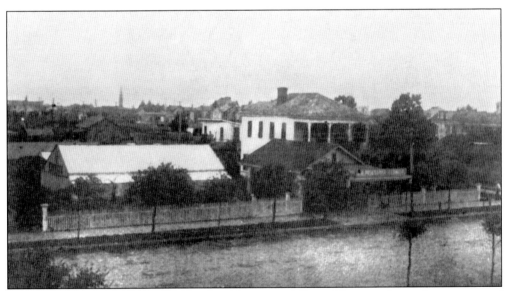

J. D. Pruessner operated the Oleander City Nursery and Green House at the southwest corner of Tremont Street and Avenue N. Known as the "Lost Bayou" area of town, it was once the site of Hitchcock Bayou before that was filled in during the 1870s. Residents described it as "a disease-breeding area that would go dry in the summer and leave thousands of decaying fish and crabs to pollute the air."

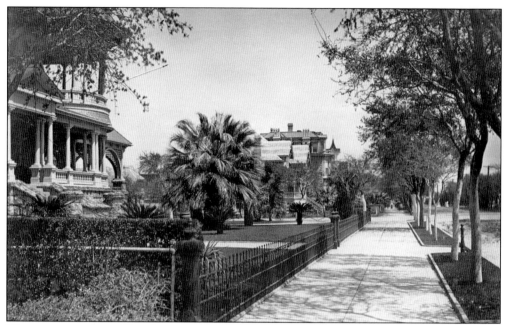

The eastern reaches of Broadway Avenue were once lined with one large mansion after another, often taking up one-quarter of a city block. Here is the front of Nicholas Clayton's house for John Charles League (extant) at 1710 Broadway. Beyond that along the north side of the boulevard were the Ricker, Trueheart, and Sawyer/Flood houses, now demolished. (Courtesy Galveston County Historical Museum.)

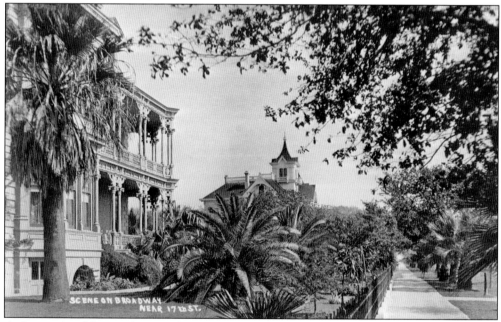

A closer view of the Trueheart and Sawyer/Flood residences bridging the north side of Sixteenth Street and Broadway Avenue reveals the level of skill and intricate design that went into them. They once stood equally as a monument to the master craftsmen who built them and to the men who financed their construction. (Courtesy Galveston County Historical Museum.)

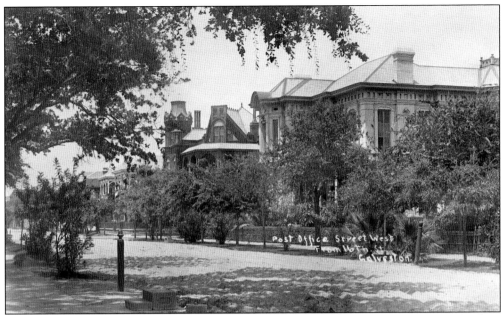

This photograph, taken on August 6, 1907, looks northwest from the 1500 block of Postoffice Street. The residence of Bertrand Adoue once stood across from the home of Henry A. Landes (extant). Hitching posts and carriage stones were common features in the streetscape. The dry summer months made navigation of sandy streets in the residential areas difficult. (Courtesy Galveston County Historical Museum.)

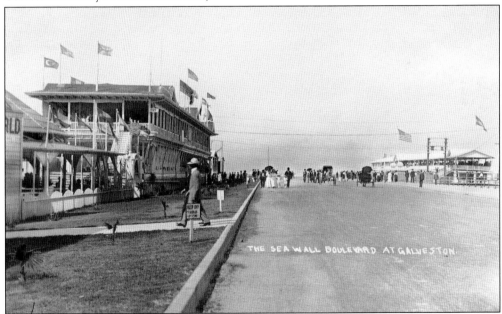

After the 1900 storm, Galveston promoted itself as a place to visit the sea that only years before nearly destroyed the city. West of Tremont Street, women in long dresses and men in suits and hats passed newly planted palms on their way between the Electric Park, arcades, and bathhouses along Seawall Boulevard. This determination to rebuild on the heels of tragedy and welcome visitors to the island continues today. (Courtesy Galveston County Historical Museum.)

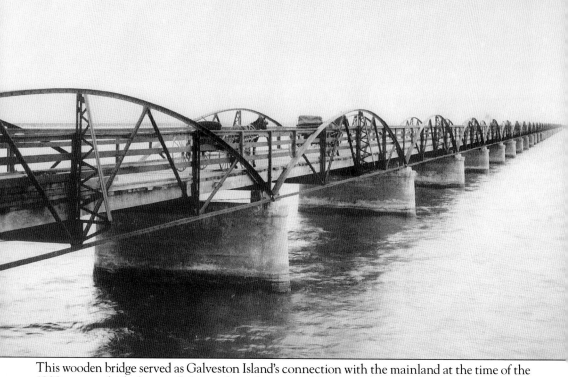

This wooden bridge served as Galveston Island's connection with the mainland at the time of the 1900 storm, which destroyed the roadway. It was quickly repaired and used until a new concrete causeway was constructed in 1911. A settlement at Virginia Point, on the north side of the bridge, prospered in the second half of the 19th century.

ABOUT GALVESTON
HISTORICAL FOUNDATION

Galveston Historical Foundation (GHF) was incorporated in 1954 in response to efforts to demolish the 1839 home of Samuel May Williams, a ships merchant, banker, and father of the Texas Navy. Plans called for the house to be razed and replaced with three brick cottages until members of the Galveston Historical Society formed the new organization, with bylaws that allowed them to purchase property. From that grassroots group of volunteers, GHF grew into one of the largest local-level historic preservation organizations in the country. Thousands of members, volunteers, and visitors to Galveston Island support the efforts of fund-raisers like the annual Historic Homes Tour and Dickens on the Strand, which raise awareness of the usability and character of historic buildings. The nonprofit organization is a strong advocate for neighborhoods and the continued use of historic buildings. Staff members assist with research and instructions on proper rehabilitation techniques through a preservation resource center, demonstration classes, tours, lectures, and special events. GHF's successful Revolving Fund has been instrumental in stabilizing and protecting more than 90 buildings since the early 1970s. For more information and to become a member, please visit www.galvestonhistory.org.

DISCOVER THOUSANDS OF LOCAL HISTORY BOOKS FEATURING MILLIONS OF VINTAGE IMAGES

Arcadia Publishing, the leading local history publisher in the United States, is committed to making history accessible and meaningful through publishing books that celebrate and preserve the heritage of America's people and places.

Find more books like this at
www.arcadiapublishing.com

Search for your hometown history, your old stomping grounds, and even your favorite sports team.

Consistent with our mission to preserve history on a local level, this book was printed in South Carolina on American-made paper and manufactured entirely in the United States. Products carrying the accredited Forest Stewardship Council (FSC) label are printed on 100 percent FSC-certified paper.

MADE IN THE USA